BELFAST
THROUGH TIME
Aidan Campbell

AMBERLEY

Acknowledgements

The images in this book of old postcards and photographs have been kindly made available by a range of generous supporters including Richard McClean and Christina Ginley of the *Belfast Telegraph*, Michael McMullan of the Northern Ireland Postcard Club, Mike Maybin, an acknowledged expert on the history of the Belfast public transport system, J. J. Bonar Holmes of Yesterday's Photos and Photographic Services, Belfast Central Library and George Hewitt.

The second stage in the development of this book was to take modern photographs of the scenes today. A small band of willing photographers included John Munn and Chris Woods, Raymond Anderson and Jack Woods, Andrew Foster and myself.

Stage three was to check the historical facts, dates, names, places and narratives which accompany the images. To this end I gathered up and poured over many local history books and the list of references is included. Chris Woods kindly carried out some grammatical pedantry during his proof reading.

Apologies for any errors or oversights which may have occurred as a result of dealing with the huge volume of information consulted in the production of this book.

Pro Tanto Quid Retribuamus

The motto on the Belfast City coat of arms, which is translated as 'what shall we give in return for so much'.

'Belfast is a city which, while not forgetting its past, is living comfortably with its present and looking forward to its future.'

James Nesbitt

First published 2016

Amberley Publishing
The Hill, Stroud, Gloucestershire, GL5 4EP
www.amberley-books.com

Copyright © Aidan Campbell, 2016

The right of Aidan Campbell to be identified as the Author of this work has been asserted in accordance with the Copyrights, Designs and Patents Act 1988.

ISBN 978 1 4456 3632 0 (print)
ISBN 978 1 4456 3660 3 (ebook)

British Library Cataloguing in Publication Data.
A catalogue record for this book is available from the British Library.

Typesetting by Amberley Publishing.
Printed in Great Britain.

Contents

Introduction

Belfast is the capital and largest city of Northern Ireland and the seat of the devolved government and Legislative Assembly at Stormont. Northern Ireland came into existence in 1921 following the Government of Ireland Act and has emerged from a period of civil conflict during 1969–98 known as the 'Troubles'. Belfast is the second largest city in Ireland and the seventeenth largest city in the United Kingdom. The population of Belfast City Council following the 2015 Review of Public Administration now exceeds 339,000 inhabitants.

The modern history of Belfast (Irish: *Beal Feirste* 'mouth of the sandbank ford', Ulster Scots: *Bilfawst*) dates back to 1613 when Sir Arthur Chichester was granted Belfast Castle and much of the surrounding land plus a charter from King James I which created a corporate borough or town. Belfast has the distinction of being the only town in Ireland to be owned by one family, the Chichesters, later the earls and finally the marquises of Donegall. Their influence in the early days of Belfast remains in numerous places and thoroughfares which bear the names of family members. Some examples include Chichester, Donegall, Arthur, Catherine, Amelia, Eliza, Charlotte, Franklin and Glengall.

Belfast made the transition from small market town to provincial capital. The population of Belfast had grown substantially from 1800 when there were only 20,000 inhabitants to a population of 349,000 in 1901. In 1888 Belfast was granted a city charter by Queen Victoria and the role of mayor was elevated to that of lord mayor. Belfast had become the third largest port in the United Kingdom and generated customs revenues only exceeded by London and Liverpool.

Belfast was on the ascendancy. It was originally a commercial town lacking in raw materials but was in a strategic position with a ford across the River Lagan. The shallow Lagan Estuary was eventually dredged of the muddy 'sleech', on which much of central Belfast is built, and widened, thus improving the seaward approaches to the harbour so that larger shipping vessels could gain access to deliver large quantities of raw materials including coal and leave with exports of locally produced goods. Belfast became an industrial power house with great shipyards, linen mills, rope-works, iron foundries, engineering works, whiskey distilleries and tobacco factories. The population grew dramatically after the traumatic Great Famine years of the 1840s and 1850s when an influx of people came from the countryside seeking work in the burgeoning industrial town. When the town expanded the boundaries were extended to swallow up much of the surrounding countryside or suburbs, although many of the old Anglicized Gaelic townland names still survive. As the environment in Belfast was quite unhealthy due to the smoke and fumes from industry and homes, the business owning and upwardly mobile middle-classes moved out of the town centre and built plump and prosperous villas on the elevated, leafy and airy foothills surrounding the town.

The invention of photography and the popular use of postcards faithfully records the history of Belfast since late Victorian times. In a way postcards could be described as the 'social media' of the day. With the immediacy of modern technology such as the internet and mobile phones it can be easily forgotten that the pace of life years ago was much less hectic and photographers worked in more patient times when there was little road traffic.

The theme of *Belfast City Through Time* is to take a geographical journey around much of Greater Belfast through the medium of an old image and compare it with a modern view. This is accompanied by a narrative commenting on the history, development or demise of the subject matter.

The scenes range from various means of public transport (and infrastructure) such as trains, trams and trolleybuses which enabled the mobility of the population to travel around Belfast. There are also landmark public buildings and developments which express something of the Victorian and Edwardian grandeur of the city such as the Custom House, Harbour Office, City Hall, Old Exchange and the shopping precincts of Donegall Place, Royal Avenue and High Street.

There are many views of buildings which incorporate the city's spiritual and religious past including churches, ecclesiastical institutions and related educational establishments. The city's physical and social wellbeing is covered in a range of images which include parks and theatres.

Social and landscape change comes through in the images of big houses, small houses, villages and industrial settings, which have either been demolished or dramatically altered in the rush to modernise and redevelop.

A lot of the trees which were newly planted in Belfast at the time of the photographs have grown up over the past 100 years.

I hope that readers will take a copy of this book with them on a journey around the city and stand (where possible) in the same place as the photographer did years ago and become acquainted with some of the history of Belfast.

Aidan Campbell

1. East Belfast, Upper Newtownards Road, Dundonald, Knock, Cregagh, Belmont

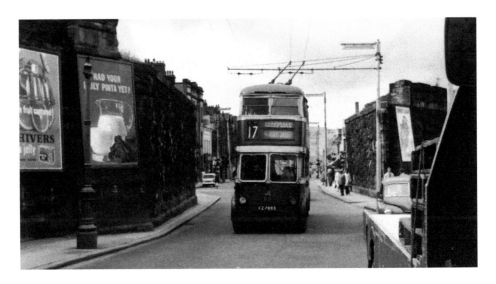

Holywood Arches

The Holywood Arches were railway bridges that carried the Belfast & County Down Railway (BCDR) line across the Holywood Road and Upper Newtownards Road (pictured in 1962) to Newtownards via Comber from May 1850. However, they are not located in Holywood and are not arches. The BCDR has been described as 'a child of the 1846 railway mania'. The line was closed in 1950 after nearly 100 years in business and the railway arches were later demolished. However, the stone pillars were left in situ for several years and then demolished in the 1960s. Unfortunately as road traffic increased this created a well-known bottleneck on the main road to Stormont Parliament Buildings, the seat of government in Northern Ireland, and there is barely enough space for this trolleybus to pass.

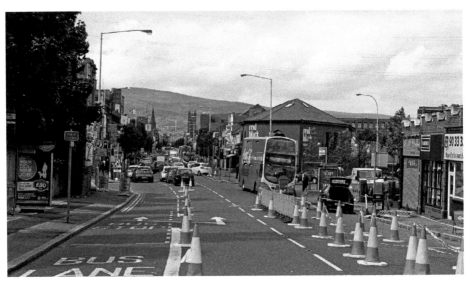

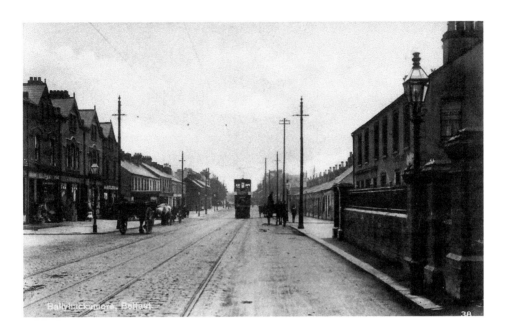

Ballyhackamore Village

In Victorian times Ballyhackamore (Irish. Baile an Chacamair – 'townland of the slob land') was a small village on the outskirts of East Belfast. It takes its name from the surrounding townland and developed around a crossroads with the Belfast & County Railway station close by at Neill's Hill on Sandown Road. It became a service village with many shops and a population of people who worked in the grand houses and estates of the wealthy business-owning and middle classes at neighbouring Knock and Belmont. Note how little road traffic there is at Ballyhackamore in this pre-First World War scene. A single tram heads towards Belfast and a few horse-drawn vehicles are probably making deliveries to the small shops in the area.

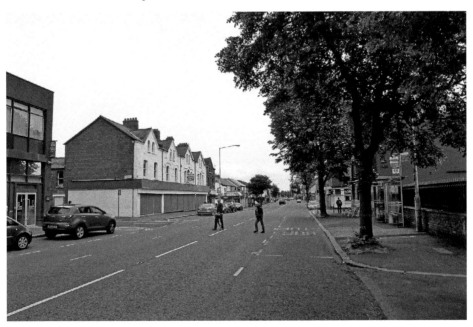

7

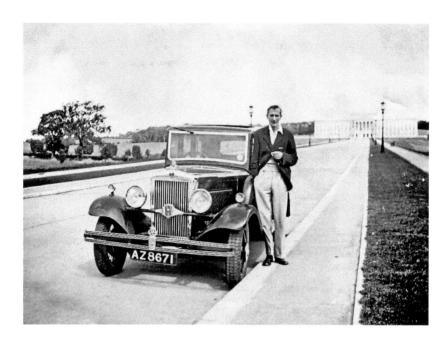

Stormont

Carse Burton was once President of the Irish Lawn Tennis Association and a keen sportsman who also owned a sports shop at Wellington Place, Belfast. He is standing alongside his father's expensive Morris Isis car, which had the very latest sliding sunroof, outside the newly opened (1932) Northern Ireland Parliament Buildings at Stormont. This is an interesting setting which shows that the trees and shrubbery have not yet matured. Parliament Buildings are now set in a 235-acre estate which has been developed as a public amenity to include a walk and fitness trail with sculptures, a children's play park and various outdoor events.

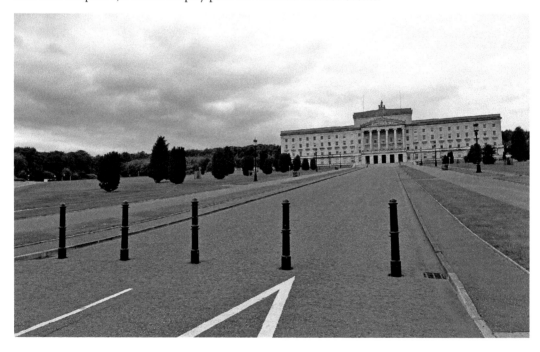

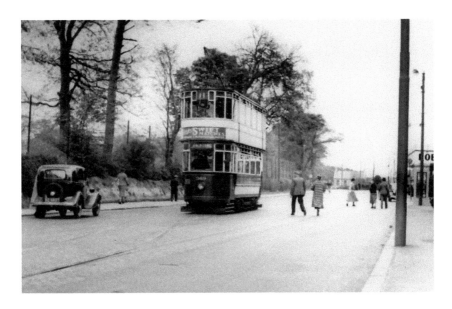

Dundonald Cemetery

The Belfast Corporation Act of 1923 allowed for the extension of the tramlines from the City Boundary at Rosepark to the gates of Dundonald Cemetery, which are just to the right out of sight. In the distance at the junction of the Comber Road are the premises of John Bell, spirit merchant (later known as the Elk Inn). Bell's pub was also the location of the hairpin bend of the Ulster Tourist Trophy road race, which was run on a 13.7-mile circuit on the public highway via Newtownards and Comber from 1928–36.

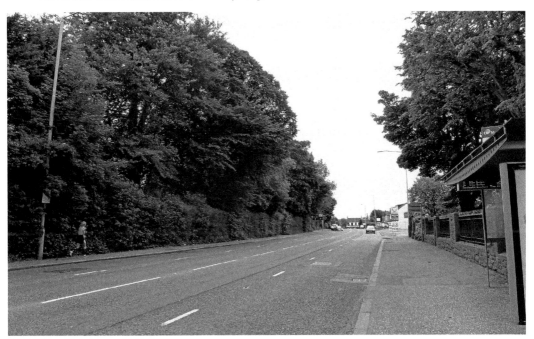

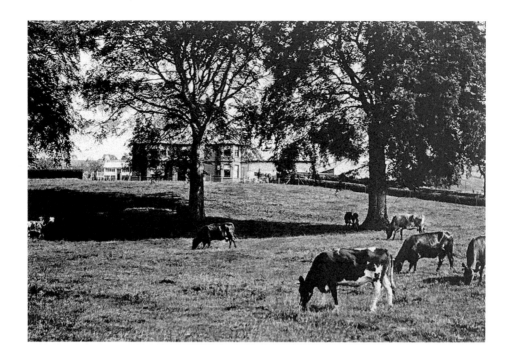

The Beeches

The Kirkwood family had owned 'The Beeches' dairy farm (*above*) since the early 1800s. It extended to over 70 acres in Ballyregan townland, Dundonald. The farmland was sold as the site for the new Ulster Hospital in the 1950s and opened by the Duchess of Gloucester in 1962, who described the new buildings (below) as strangely 'not only of functional excellence but also of distinctive beauty'. The old Ulster Hospital for Children and Diseases of Women was based at Templemore Avenue in East Belfast but had been destroyed by the Luftwaffe during the Blitz of 1941.

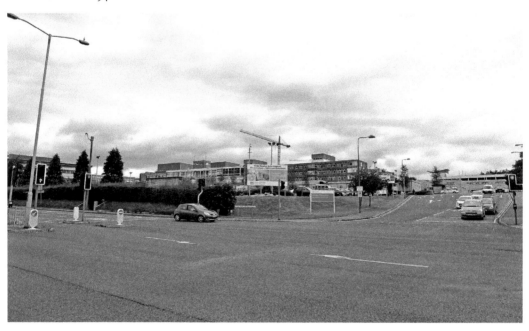

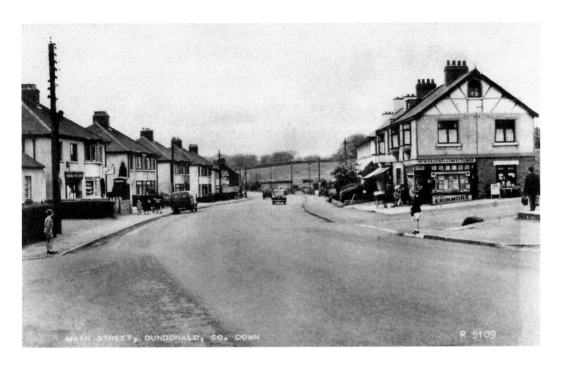

Dundonald Village

In the mid-1950s Dundonald was a village on the outskirts of Belfast. On the left-hand side of the Upper Newtownards Road the semi-detached housing had been constructed in the 1930s on the site of a row of country cottages known as 'Gape Row'. They were made famous in a novel of that name by a lady called Agnes Romilly White whose father had been the rector of St Elizabeth's parish church just prior to the First World War. This photograph (above) was taken shortly before the construction of the Ulster Hospital on the hill in the distance.

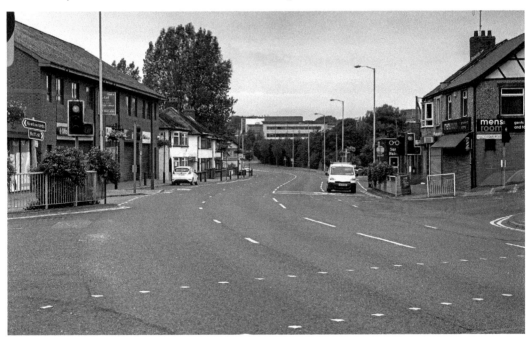

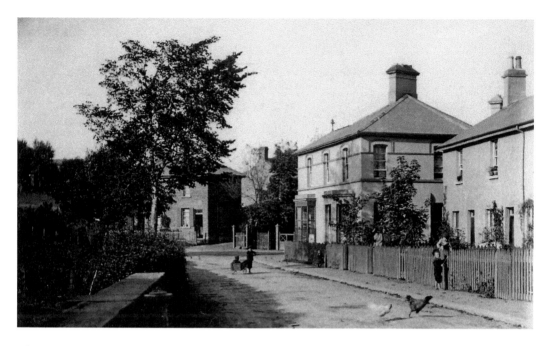

Cherryvalley Village

Fred Hurley's father was a wealthy tea merchant who lived at a big house called 'Beaconsfield' on Knock Road. In the summer of 1895 young Fred's birthday present was the very latest photographic technology, a half-plate camera with tripod. He took this photograph of 'Knock Village' which was the original name for Cheryvalley later made famous by local comedian James Young who joked about the genteel ladies who lived at 'Cheeryvallee'. Notice the Belfast City boundary post at the Knock River bridge and wee bantum hens running across the Gilnahirk Road.

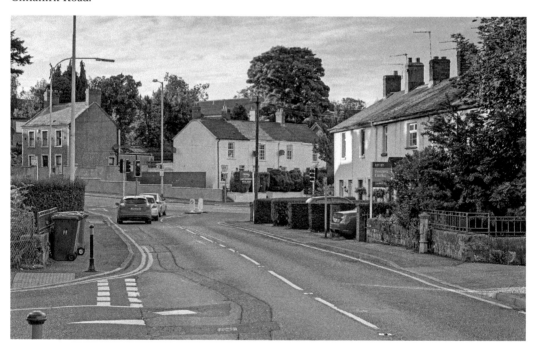

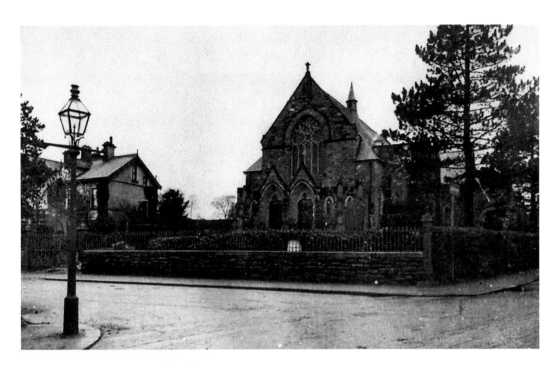

Knock Presbyterian Church

The name of the King's Road was adopted in honour of the Coronation of King Edward VII in 1902. At the junction of the King's Road and Knock Road stands Knock Presbyterian Church, which was constructed in 1874 and until 1921 was known as Dundela Presbyterian Church. In front of the big house to the left, which was called 'Closeburn', there is a metal arch over the gate to the church with the words 'Dundela Presbyterian Church', which dates this photograph to a pre-1921 vintage. Notice the gas street lighting which illuminated the area until the 1960s.

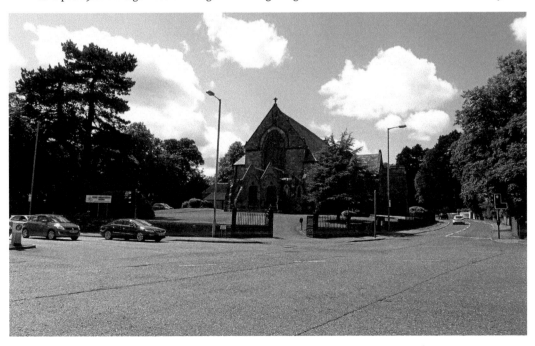

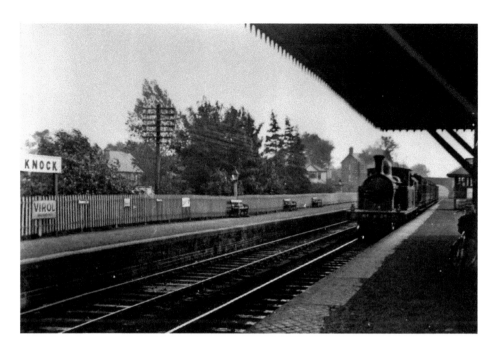

Knock Railway Station

The BCDR line reached Knock in 1850 and a stopping place at this location was known as Ballycloghan Halt (Irish: townland of 'the stepping stones') and later as Knock Station with brick station buildings constructed in 1895. The BCDR was closed in 1950 after ninety-nine years and eleven months in business. The railway track bed is now a 7-mile-long cycle and footpath called the 'Comber Greenway'. Everything in this 1940s view of Knock station is now gone except the chimney of a house on King's Road, just to the left of the steam train, which survives to the present day.

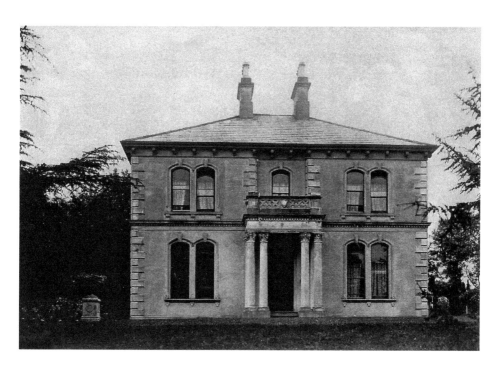

Beaconsfield

Beaconsfield was a big house situated on the corner of Kensington Road and Knock Road. It was built during the late Victorian period in 1869 by a wealthy insurance agent called Joseph Millar. The last resident of Beaconsfield was Miss Alice Maud Crawford (one of the Crawford's of Crawfordsburn) who lived there from 1935 until her death aged ninety-four in 1960. The Marie Curie Memorial Foundation bought the house and extensive site and opened Beaconfield Nursing Home, now the Marie Curie Hospice, in 1965.

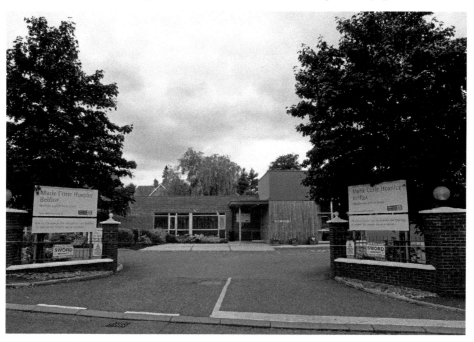

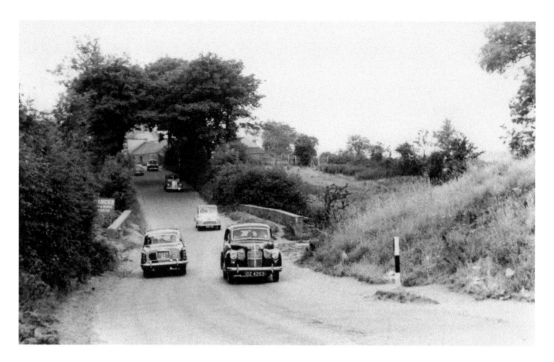

Hillfoot Road

A small river called 'Knock Burn' flows under the old Hillfoot Road in 1959 from the direction of what is now the Braniel Housing Estate in the direction of Orangefield. However, road traffic volumes were increasing and the Hillfoot Road was to be replaced by the A55 Upper Knockbreda outer ring dual carriageway, which was planned to extend around East Belfast from Belvoir to Knocknagoney in the early 1960s. But the residents of the Knock area objected and there is now only a single carriageway on the stretch from Clara Park to the Upper Newtownards Road.

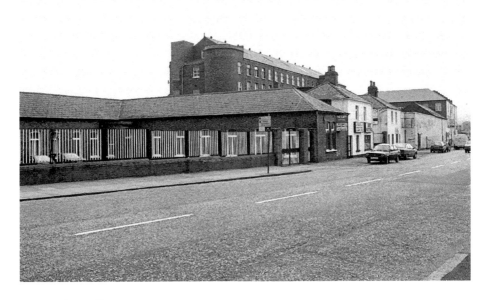

Loop Bridge Mill

Griffith's Valuation of Tenements for 1863 notes that the 'Loop Bridge Mill' (so called due its close proximity to the Loop River) in the townland of Ballymaconaghy (681 acres) was owned by Alexander, William and John Moreland. The location in those days was a rural one on what is now Castlereagh Road in an area which is heavily built-up. By 1894 the mill was taken over by printers McCaw, Stevenson & Orr and renamed 'Linenhall Works' after the original address of the business at Linenhall Street, Belfast. Part of the industrial heritage of Belfast, in 2011 the old mill buildings were replaced by a new Tesco store.

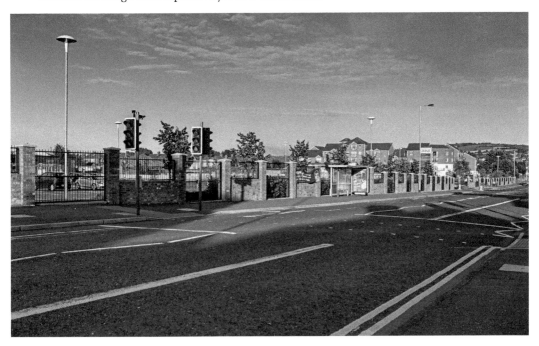

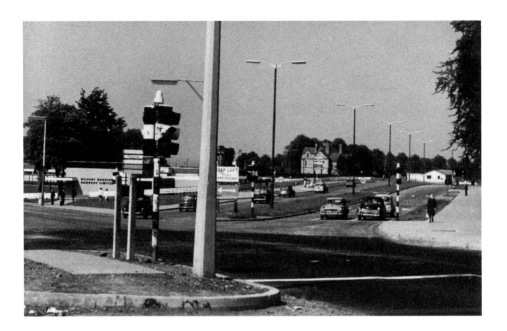

Supermac

In 1962 a local retailer attended a seminar on the relatively new concept of 'Out of Town Shopping' in Dayton, Ohio, and became convinced that the future of convenience shopping lay in the development of shopping centres on the perimeter of cities readily accessible by car. A 10-acre site at Newtownbreda was considered appropriate, although the A55 dual carriageway had not been completed. The crossroads was small and there was a petrol station, a farmhouse and a disused factory unit on the land which stretched as far as Upper Galwally. 'Supermac' (the name was the winner from a competition held in local schools) opened in October 1964, along with ten shop units plus a bank, and brought the retail revolution to the British Isles. Sainsbury's built a new store on this site, now known as Forestside, in 1997.

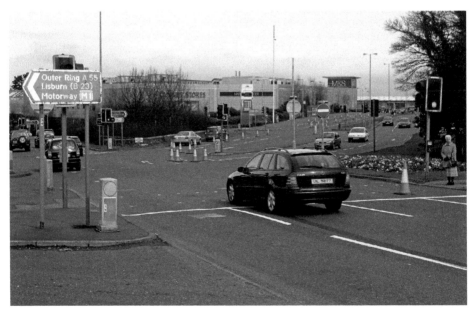

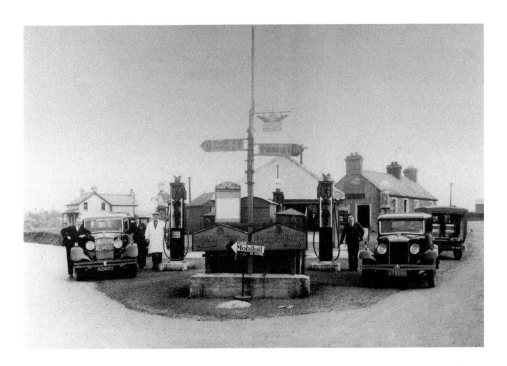

Carryduff

This is the junction at Carryduff (Irish: townland of 'Black-haired Hugh's Quarter') on the outskirts of S.E. Belfast with Saintfield Road, left, and Ballynahinch Road, right. In 1933 during the early days of car ownership there was a petrol station beside the site of the present roundabout (above). The business was owned by George Johnston and included pumps for well-known petrol brands BP, Shell, M.S. and Crown. The petrol station was demolished in 1968 and a chiropodist now occupies this highly visible retail location.

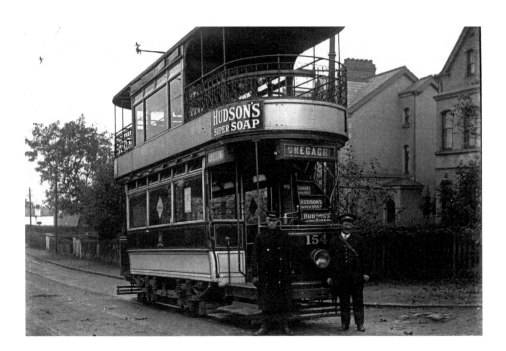

Cregagh Village

An electric tram is parked at the terminus at the top of Cregagh Road in 1910 where it meets the Hillfoot Road. Horse-drawn trams reached this suburb of Belfast in the 1890s when the area was known as 'Cregagh Village' (Irish: townland 'The Rocky Place') and it consisted of grand middle-class housing which included Downshire Road, Everton Drive and Cregagh Park. Electric trams were open-topped initially and then fitted with top covers for protection in wet weather. But it was decided that the trams should have open cabs because it was believed this was healthier for the drivers, although it is difficult to imagine that the weather was any better back then than it is today.

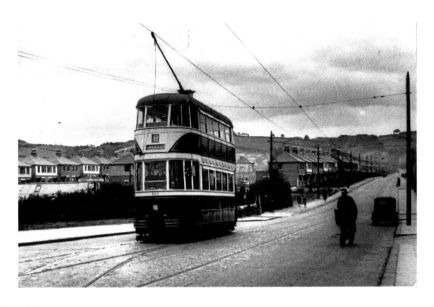

Bells Bridge

Nowadays 'Bell's Bridge' on Cregagh Road is known as a major roundabout (below) connecting Ladas Drive and Mount Merrion Avenue, but it was previously a small bridge over the Loop River (look just in front of the tram). The tram lines had reached Gibson Park by 1898 but the line above Bell's Bridge was abandoned in 1936 because of the poor surface. Passengers took a bus to the junction at top of the road. The boundary between the Belfast and Castlereagh Council areas was also reached here.

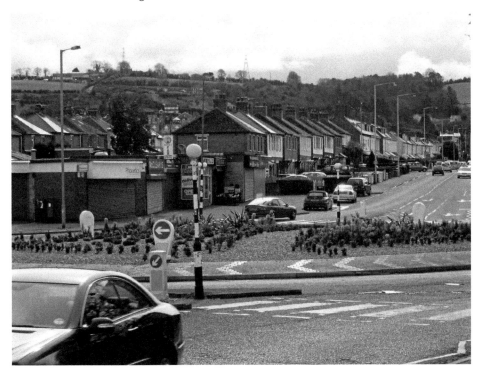

Canmer Buildings

Canmer Buildings on Albertbridge Road not far from the River Lagan are pictured in 1980 shortly before demolition. John Canmer is mentioned in the Belfast Street Directories of the 1850s as the 'Lagan Bridge toll collector'. By 1877 Catherine Canmer had an address here at 1 & 3 Albertbridge Road and is described as a 'spirit dealer'. The Lagan Bridge would later be renamed Albert Bridge in memory of Prince Albert. Notice the small tower in the distance which is the last remnant of the electricity generating station.

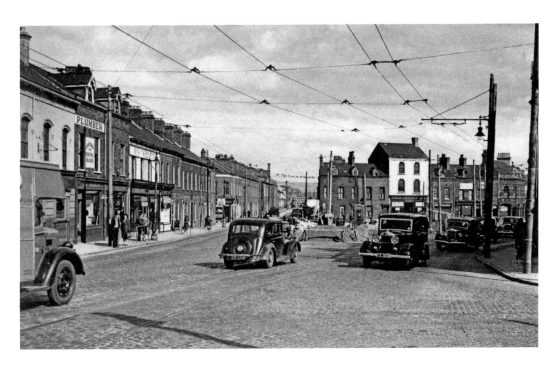

Albertbridge Road

It looks as though a funeral cortege headed along the Albertbridge Road, approaching the Albert Bridge in 1948 and a roundabout is under construction in the background in front of Madrid Street. This is one of two important gateways across the River Lagan into East Belfast, the other being the Queen's Bridge. All the buildings in sight have been demolished, most of Madrid Street is gone, the overhead powerlines for the trams and trolleybuses have been removed and the roads greatly widened.

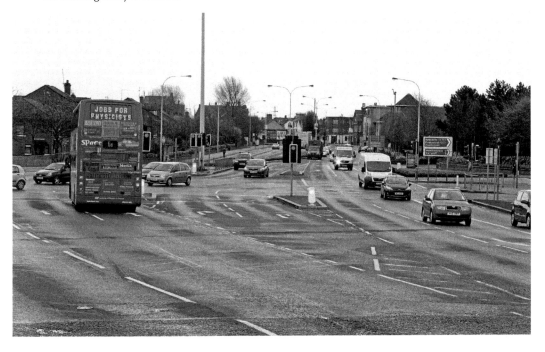

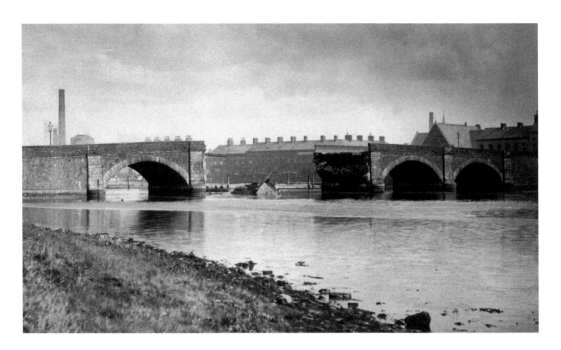

Albert Bridge

The Lagan Bridge (or Halfpenny Bridge, so called because of the toll charge) collapsed in 1886 and a new bridge called the Albert Bridge was opened in 1890. The large building to the right of the bridge is Albertbridge Congregational Church located on Short Strand. It was built in 1866 facing the River Lagan and a sandy shore. The church was something of a landmark, on entering East Belfast from the Albert Bridge, as in recent years it had an illuminated sign which bore a scriptural message. This church building was demolished in 1985 and a new church built at neighbouring Woodstock Link.

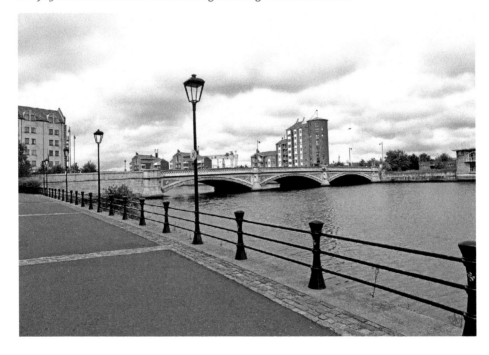

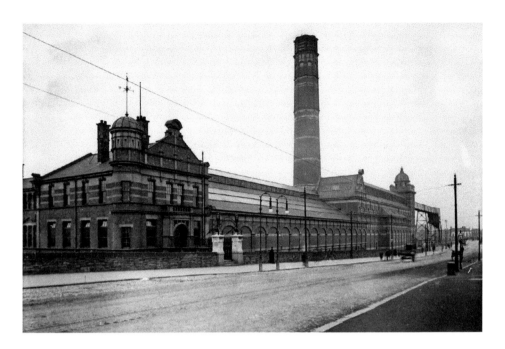

East Bridge Street

Across the Albert Bridge the road becomes East Bridge Street, and on the corner of Laganbank Road this was how the municipal electricity works and offices, described as 'late baroque' in architectural style, looked in 1943. This power station was opened in 1898 and was the second to be opened in Belfast. A small predecessor had been opened at Chapel Lane in 1895, built to supply the needs of the growing city. The electrification of the horse-drawn tramway system was completed in 1905, and the last of the power station buildings was demolished in the 1980s. Santander Bank (below) now occupies the site although the gateposts of the power station have been thoughtfully retained.

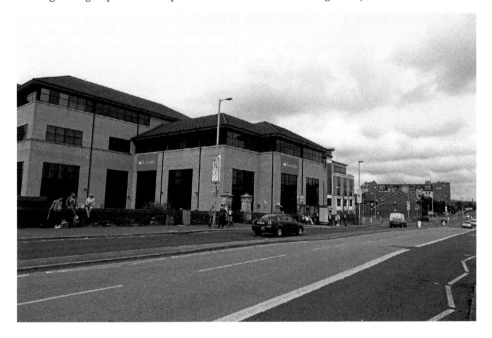

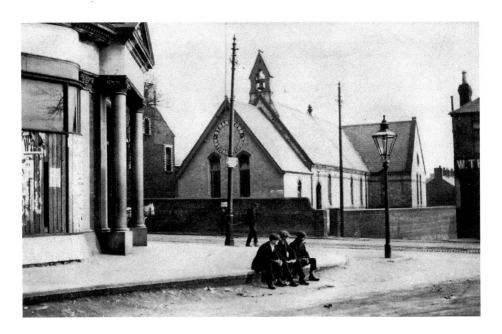

Gelston's Corner

The townland of Strandtown straddles the Belmont and Holywood Roads and originally reached the sandy beach, or strand, at Belfast Lough. There were no traders recorded in the area in 1859 but by 1861 James Gelston is listed in this vicinity as a 'grocer and spirit dealer'. In this fairly quiet scene at Gelston's corner in the early 1900s the three gentlemen sitting on the kerbside seem relatively untroubled by passing traffic. In the background is the original Strandtown National School which relocated to spacious new premises on North Road in 1931. The school building has an ecclesiastical look to it and it was constructed in 1863 as a chapel of ease for the local Church of Ireland congregation before St Mark's Dundela was consecrated in 1878.

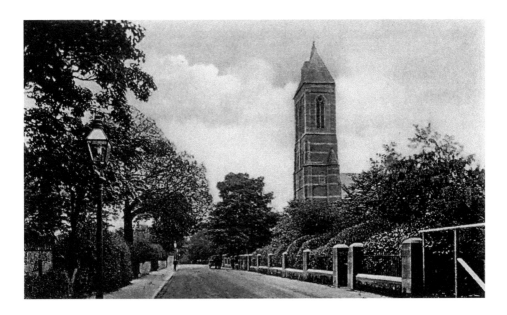

Holywood Road

St Mark's Church of Ireland, Dundela, is located on Holywood Road at the junction with Sydenham Avenue and stands in a prominent position, where its 150-foot bell tower provides a very conspicuous landmark. This hill, 'Bunker's Hill', according to local folklore, took its name from the site of a famous battle of the American Revolutionary War in 1775. St Mark's Church was consecrated in 1878 and the first rector was Revd Thomas Robert Hamilton whose daughter Flora married Albert Lewis. They had a family of two boys, Warnie and his younger brother Clive Staples – or C. S. Lewis – who would go on to write *The Chronicles of Narnia*.

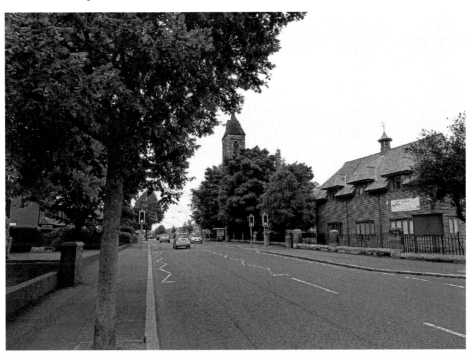

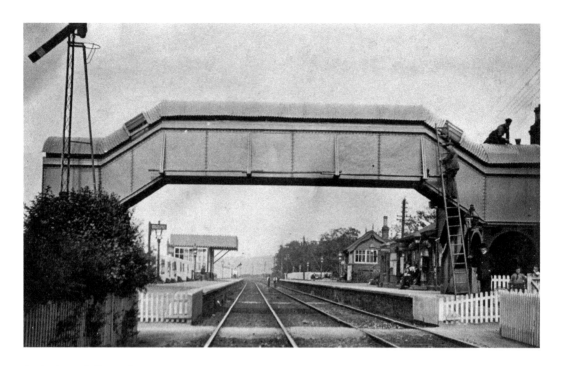

Sydenham Railway Station

The Belfast & County Down Railway, Sydenham station as it looked in 1929. The station was originally (in 1848) known as 'Ballymisert Halt', (Irish: 'townland of the plain') having taken its name from the surrounding townland. In those days it was a mere stopping place without a platform until the name of 'Sydenham' was imported from a borough of London (a fashionable thing to do in Belfast during Victorian times) and adopted for the district in 1856. This stretch of line was then operated by the Belfast Holywood & Bangor Railway who built brick station buildings in the 1870s, but these were demolished in the 1960s.

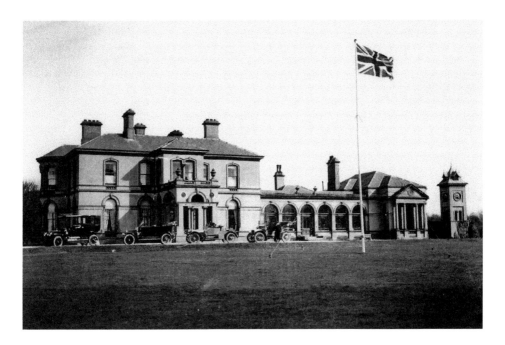

Craigavon

Craigavon House was built in 1870 and became the home of Capt. James Craig, later Sir James Craig, and first prime minister of Northern Ireland. It was at Craigavon House in September 1911 that Sir Edward Carson and Capt. James Craig organised a huge protest demonstration against Home Rule involving 50,000 men, which led to the formation of the Ulster Volunteer Force and the signing of Ulster's Solemn League and Covenant by nearly 470,000 people. In 1915 Capt. James Craig offered Craigavon House to the Board of Management of the UVF hospitals to be used for the treatment of sick and wounded soldiers from the First World War. In the 1990s a new 'Somme Nursing Home' was constructed nearby to replace the old UVF Hospital.

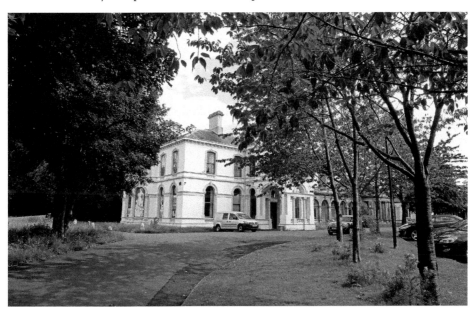

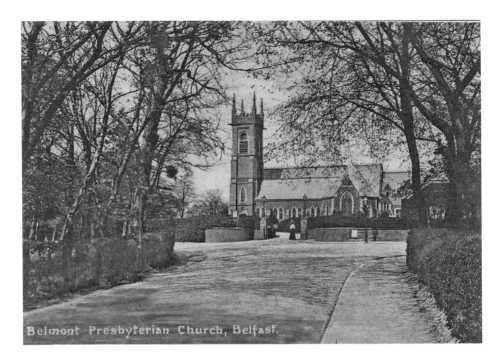

Belmont Presbyterian Church, Belfast.

Belmont

Thomas McClure was a wealthy tobacco merchant and politician who bought land in East Belfast in 1858 from the estate of Lord Ranfurley, whose name is still seen on a street in the neighbourhood. Thomas McClure lived at a mansion called 'Belmont', which was on a neighbouring site until Campbell College was built there in 1894. He was an Elder in Fisherwick Presbyterian Church in the centre of Belfast and complained that the long journey home from church made him late for lunch. So in 1859 he provided a site for a new church, Belmont Presbyterian Church (pictured above), which was opened for worship on Sunday 26 January 1862.

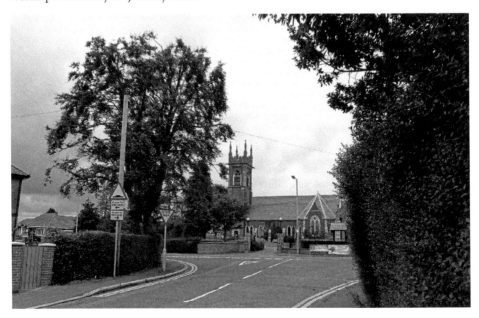

2. Central Belfast, Donegall Square, Donegall Place, Royal Avenue

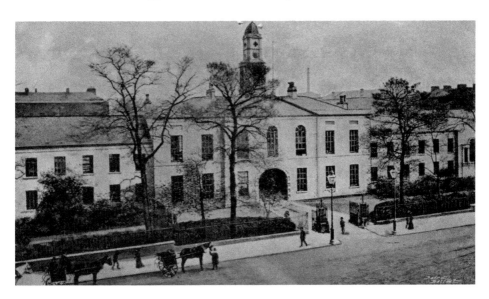

White Linen Hall

One of the oldest areas of Belfast, the city centre at Donegall Square, is now the site of City Hall (*below*) where Belfast City Council is based. The developing linen industry was a major feature of Belfast's commercial life during the eighteenth century and in 1784 the White Linen Hall (*above*) opened for business, enabling local linen producers to market and export their wares in Belfast. But the great linen warehouses and ironworks that dominated the busy streets in earlier centuries have all gone now and the much grander City Hall was opened on this site in 1906. Although Donegall Square remains as the financial and retail heart of the city, Belfast now has many out of town shopping centres.

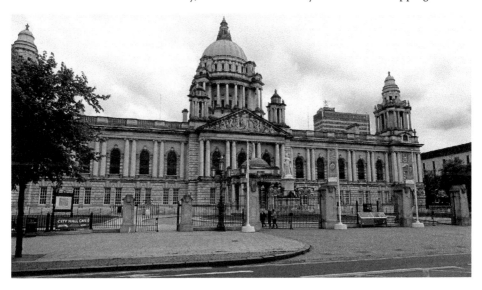

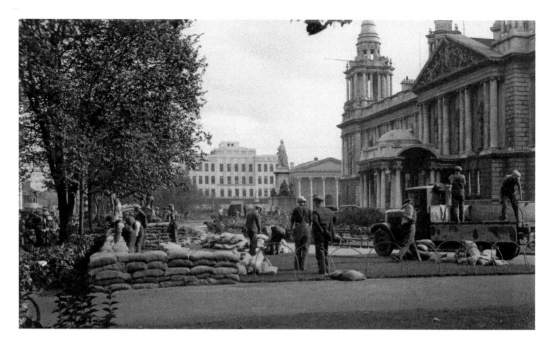

Belfast City Hall

The statue of Queen Victoria in front of Belfast City Hall was originally located in Donegall Square North but now looks in the direction of Donegall Place and Royal Avenue. The activity in the foreground involves 'building air raid shelters during the crisis, September 1938'. The Second World War would begin a year later in September 1939. The building in the distance in Donegall Square East is Imperial House, which was constructed in the 1930s on the site of the Linenhall Hotel. Alongside is the columned frontage of Donegall Square Methodist Church, built in 1847, which survives although this is now the headquarters of Ulster Bank.

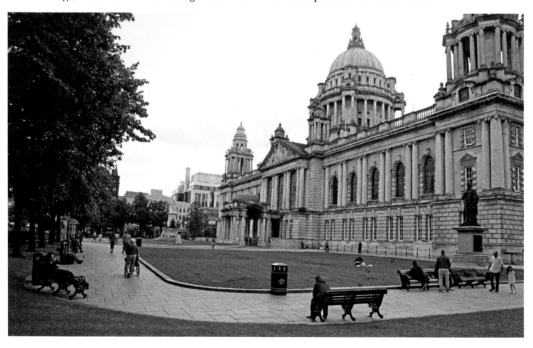

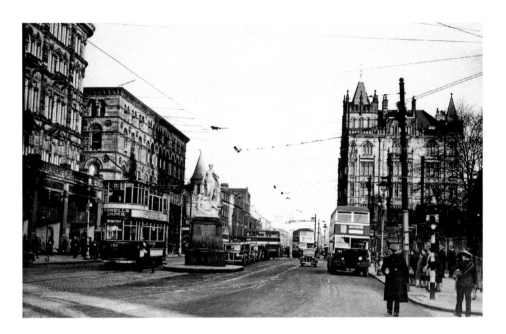

Donegall Square North

At the front of Belfast City Hall looking in the direction of Chichester Street in 1946, several of the grand old buildings from late Victorian and Edwardian times survive. To the right one the Ocean Accident Insurance buildings, completed in 1902. Richardson Sons and Owden's linen headquarters and warehouse to the left was built in 1869 and was the headquarters of the Water Commissioners for many years and is now occupied by Marks & Spencer. The tall building to the far left was built in 1888 as a department store for Robinson & Cleaver and contained the very latest technological innovation such as electric lighting and 'a luxurious passenger elevator'. A leading retailer of the day, prestigious customers included 'The Queen, Maharajah of Cooch Behar and the Emperer and Empress of Germany'. Burger King now occupies the ground floor.

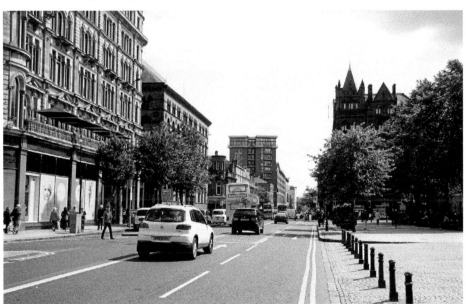

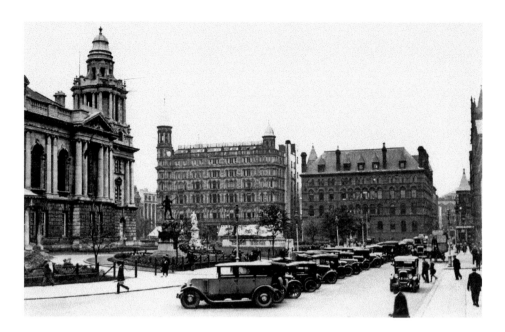

Donegall Square East

A 1928 view of Robinson & Cleaver's department store (*left*) and the Richardson Sons building from Donegall Square East. The hub of car retailing was within a short distance of Belfast City Hall as recently as the 1970s, but the showrooms have since moved to more spacious premises at Boucher Road in South Belfast. The proliferation of parked cars are from the 'motor garage and showrooms' of Harry Ferguson Ltd which are just out of site to the right alongside Donegall Square Methodist Church. In 1909 Harry Ferguson, a native of Dromore, County Down, became the first Irishman to make a powered flight and the first citizen of the United Kingdom to build and fly his own aeroplane. He is also remembered for his role in the development of the modern agricultural tractor.

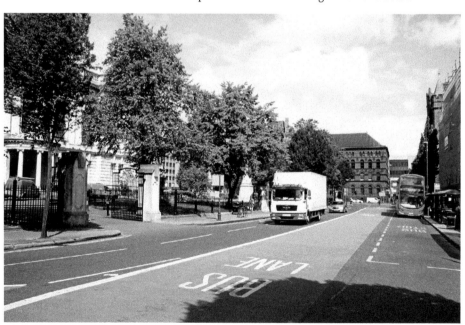

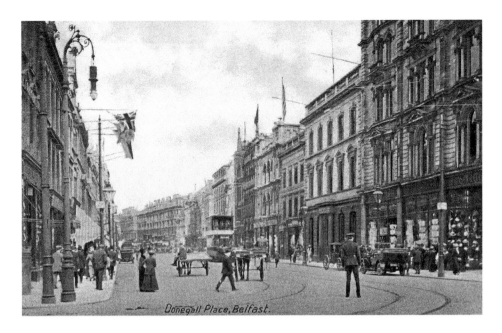

Donegall Place

Donegall Place extends from Belfast City Hall to Castle Place. This street was laid out in the 1780s as part of town improvements by landowner Lord Donegall (part of the Chichester family) whose name, along with other family members crops up frequently in Belfast street naming. By the 1800s Donegall Place was the most desirable residential area in Belfast and it was in the 1850s that the grand terraced houses became retail and other business premises. As the town grew the wealthy business owners and middle classes moved out of the city centre and built grand villas on the hills around Belfast. Notice the light traffic in this early 1900s view. There seems to be a few motorised vehicles, a single electric tram on the road, a police constable to keep things in order and a couple of horses and carts.

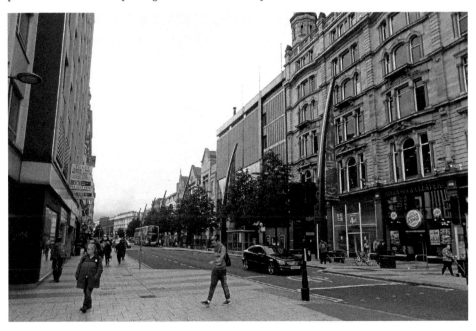

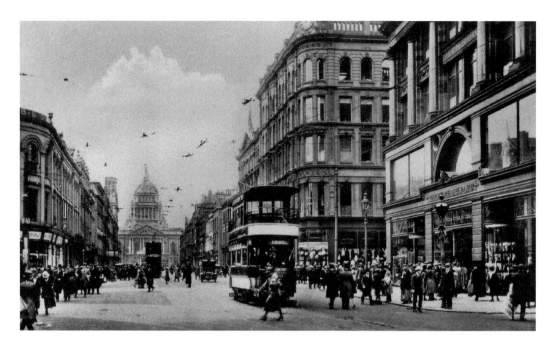

Donegall Place

When Donegall Place was built in the late 1700s it was a largely residential area for the great and the good of society and even the landlords – the Donegall family lived in a house here. Their home eventually became the Royal Hotel, where author Charles Dickens once stayed. In this 1920s view of Donegall Place from Castle Place, Belfast City Hall looms large in the distance. It looks like a busy shopping day for the leading department stores of the time including (*right*) Anderson & McAuley and the Bank Buildings, both of which have ceased trading.

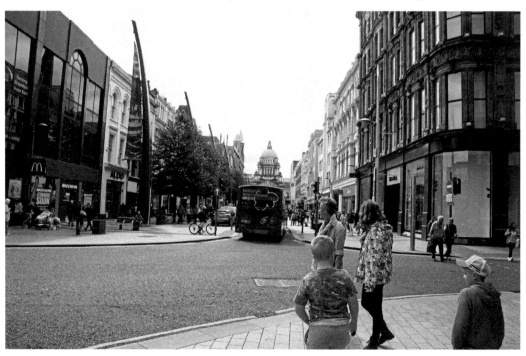

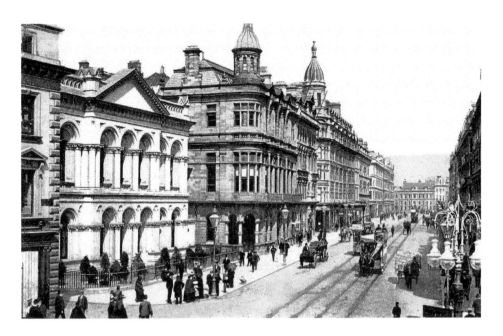

Castle Place and Royal Avenue

Royal Avenue begins at Castle Place and continues to Donegall Street. It was opened up around 1880 and replaced the much narrower Hercules Street, which mostly consisted of butchers' shops. The aim was to create a much grander and more dignified thoroughfare with more regular building lines and facades as this 1900 scene demonstrates. The white building on the left is the Provincial Bank (now Tesco Metro) built in 1867, and just beyond it the first building with the cupola is the Ulster reform Club, originally built by Ulster members of the Liberal Party to celebrate William Gladstone's victory in the 1880 UK general election. The second cupola belongs to the luxurious Grand Central Hotel, which was built in 1893, became an army base in 1972 and was demolished in the 1980s for the new Castlecourt shopping centre.

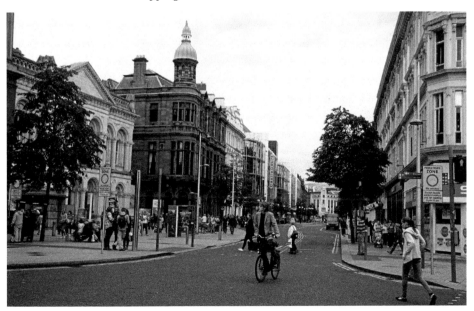

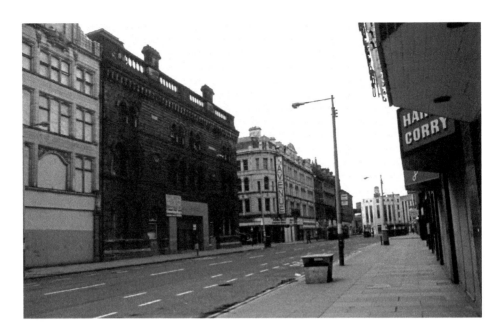

Royal Avenue to North Street

Many changes have been made in this section of Royal Avenue since 1986 (*above*) as all the buildings in sight have been demolished for redevelopment and the construction of Castlecourt shopping centre (*below*). The building with the lighter colouring (on the left) is a retail premises beside the old Grand Central Hotel. In the centre with an estate agent's sign is the vacated General Post Office, opened in 1886 and built from dark Dungannon stone, which Charles Brett described as 'grimly machiolated'. The Avenue cinema is on the corner of Garfield Street and had several name changes over the years. The Picture House was one of the pioneers of cinema in Belfast and had been established on this site in 1911. It once had an orchestra of forty musicians to provide accompanying music for silent films.

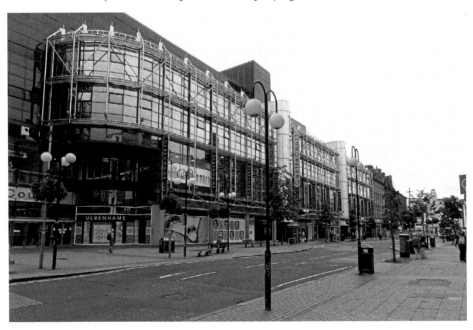

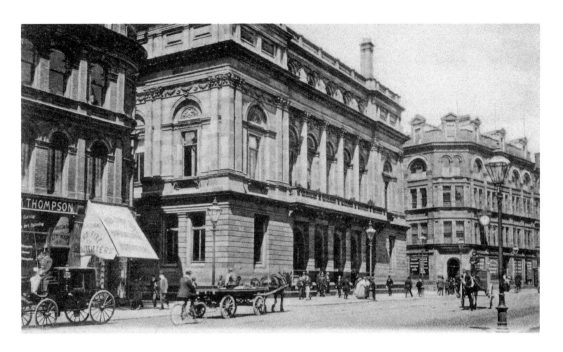

Royal Avenue to York Street

The Belfast Free Library is the large Classical building (*above centre*), with a Dumfries red-sandstone exterior, which when opened in 1888 was one of the first major public library buildings in Ireland. It was designed by W. H. Lynn and built by the local company H. & J. Martin who have been in business for 170 years and constructed many of the landmark buildings in Belfast. Just beyond the library, the offices of the *Belfast Telegraph* were opened in 1886 and a contemporary description was of 'the most imposing exterior of any newspaper office in Ireland'. There has been a recent news story that this building is now for sale.

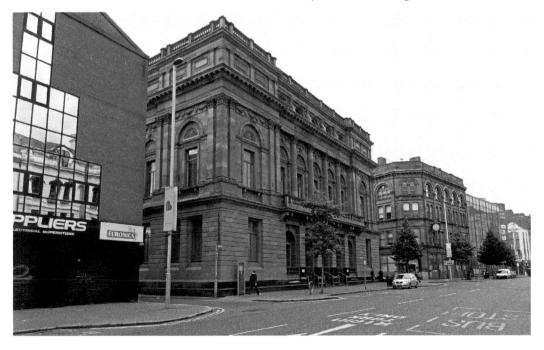

3. Central Belfast, Castle Place, High Street

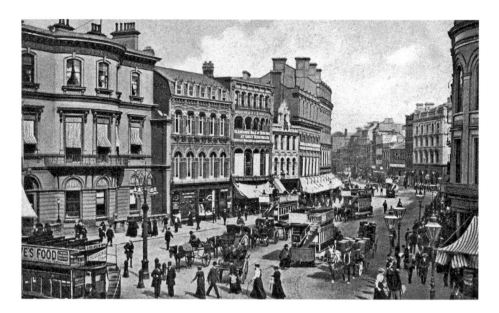

Castle Place

In 1612 King James granted the town and castle of Belfast to Sir Arthur Chichester, then Lord Deputy of Ireland whose descendants were awarded titles under the Donegall name. The original Belfast Castle was located not far from here and burned down in 1708. Castle Place leads on to High Street, which is the oldest street in Belfast. In the late 1800s Castle Place had become the centre of the horse-drawn tramway system, with its 114 cars and 1,000 horses, and it was known as 'Castle Junction', as in this 1890s view. The large bow-fronted building, above left, is the Ulster Club. Built in 1860 and demolished in 1981, it has been described as 'a rather hefty slice of Brighton'.

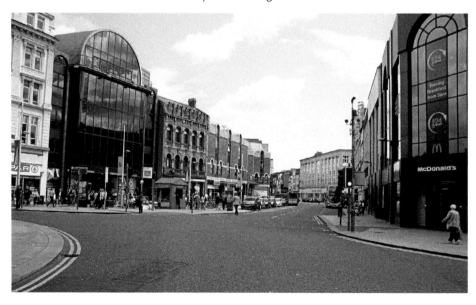

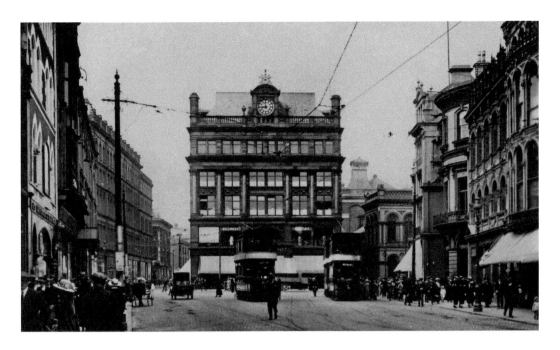

Bank Buildings

The Bank Buildings is the large building in this 1920s scene. It takes its name not from a bank but due to the fact that it is located on the bank of the culverted River Farset, which flows under High Street. This is the third Bank Buildings store located on the site since the early 1800s and each one was on a greater scale than its predecessor. A top-class department store, it was operated by the firm of Robertson, Ledlie, Ferguson & Co. who were described as 'wholesale and retail linen merchants, woollen drapers, silk mercers, general house furnishers, British and foreign warehousemen'. Primark, a discount fashion chain, now occupies the premises.

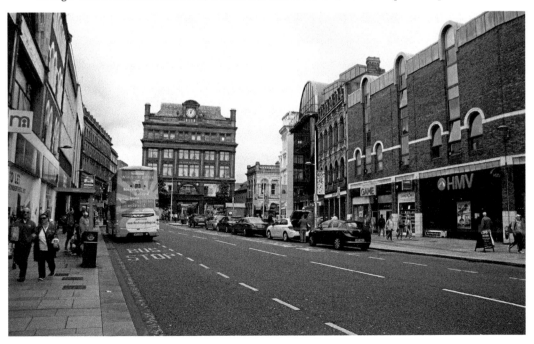

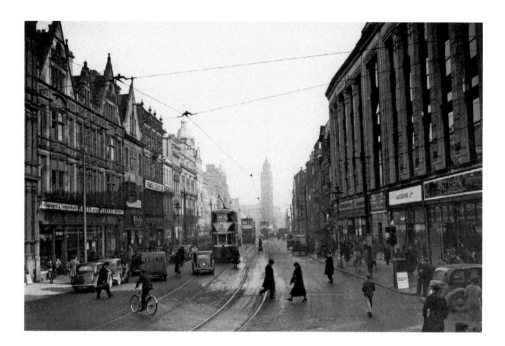

High Street

High Street follows the irregular course of the Farset River, which flows immediately underneath the road surface in a culvert. During the early 1700s several bridges spanned the Farset, and High Street contained a number of quays allowing sailing ships to dock. By the late 1800s the street was lined with great shops and the scene had changed very little by 1939 (*above*). But most of the grand buildings on the left-hand side of High Street would be destroyed in the Blitz of 1941. In the distance is the Albert Clock, built in 1869 as a memorial to the late Prince Consort. For many years the 145-foot clock tower leaned to one side and it was commented that 'it had both the time and the inclination!'

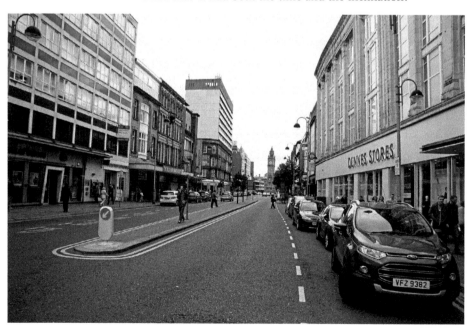

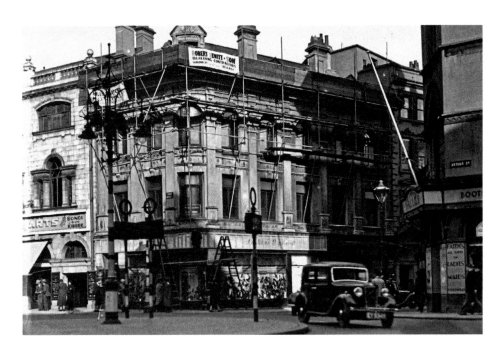

Corn Market

The car has travelled along Corn Market from High Street and is negotiating a roundabout at Arthur Square (named for one of the Donegall family) in this 1940 view. The name of Corn Market is a reminder of Belfast as a market town when grain was imported and sold by several local merchants. The builder's signage high up on the building on the corner of Ann Street (Ann was another member of the Donegall family) proclaims 'Robert Hewitt & Son, Building Contractors' who undertook much construction work in Belfast and were based on Sandown Road at Ballyhackamore. To the left is the Imperial cinema, opened in 1914 with a seating capacity of 1,000 and closed in 1959. It was once regarded as the finest cinema in Belfast.

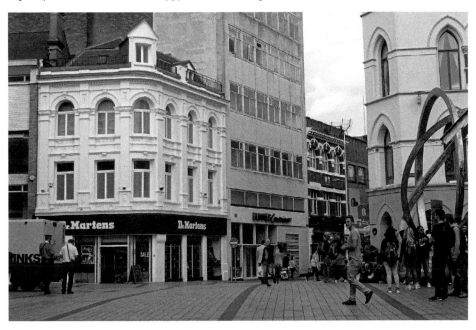

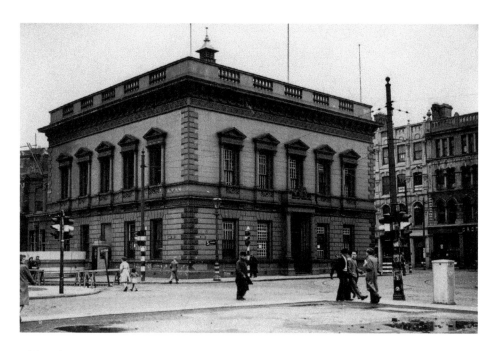

Old Exchange

The earliest public building surviving in Belfast is the 'Exchange'. Constructed as a single-storey commercial building in 1769 by landlord the Earl of Donegall, it is located in an area known as the Four Corners at the junction of Bridge Steet, Waring Street, Donegall Street and North Street. It was extended in 1776 by the addition of a second storey known as The Assembley Rooms. An historic building, in 1792 it was the venue for the Belfast Harp Festival, later used as a courthouse in the trials of members of the United Irishmen following the 1798 Rebellion, in 1845 it became a branch of the Belfast Bank, more recently the Northern Bank and now an arts centre for exhibitions and plays.

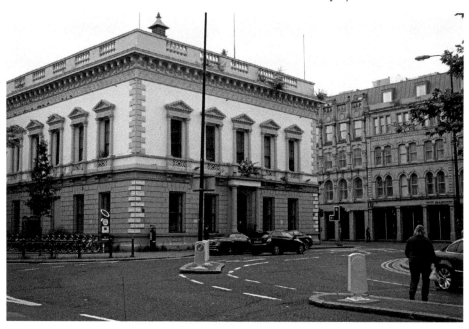

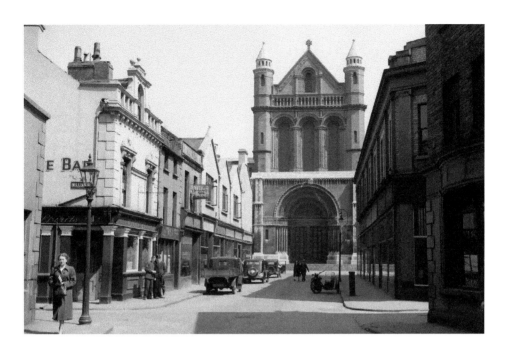

St Anne's Cathedral

The old Church of Ireland parish church of St Anne was built on Donegall Street (at Lord Donegall's expense) in 1776. It was replaced by St Anne's Cathedral, which was consecrated in 1904 although building work has continued over the past 100 years. At the time of construction it was the fourth new cathedral to be built in the British Isles since the Reformation. This 1952 view of St Anne's Cathedral is from Church Street, in an area which at the time was the merchant and warehousing centre of the city. Many of these streets and their old buildings were swept away in recent years to develop Cathedral Quarter with a focus on arts and culture.

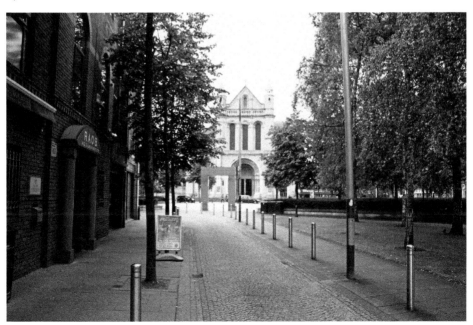

4. Central Belfast, Victoria Street, Queen's Quay, Ormeau

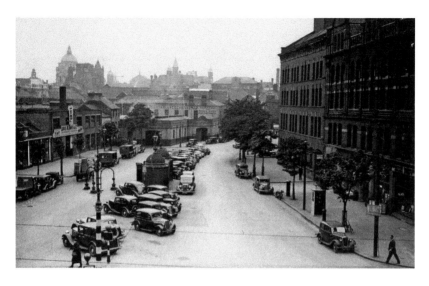

Victoria Square

When Victoria Street was opened in the 1840s it was known as Cow Lane and Victoria Square as Poultry Square. But when Queen Victoria made a royal visit to Belfast in 1849 the grander names were adopted in her honour. Victoria Square was once the home to Finlay's Soap and Candle Works, which was established in 1798 and closed down in the 1950s. The supply of clean drinking water was a problem in Belfast years ago so in 1852 the aerated mineral water company of Cantrell & Cochrane Ltd was established (in the old Town Hall) and an artesian well was sunk to tap into the underground Cromac Spring. Sparking beverages were then exported around the world. The high-end Victoria Square shopping centre was opened, with an impressive domed roof, on the site in 2008 with the Jaffe Memorial Fountain (*below*) positioned at the entrance.

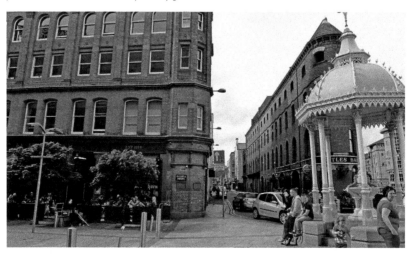

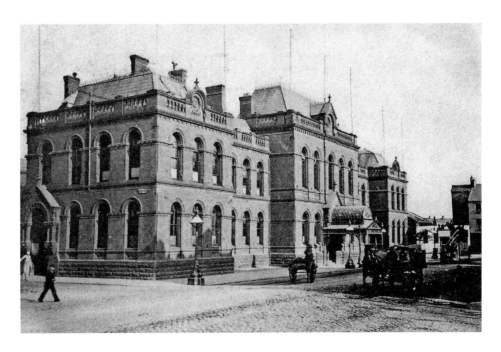

Town Hall

The architect Anthony Jackson was chosen to design a new Town Hall for Belfast in 1869 and it was opened the following year. The design was described as being 'of sturdy brick construction in mixed elements of a Venetian gothic style' and not admired by everyone in rapidly growing Belfast. Apparently Anthony Jackson had gotten his inspiration from drawings made on holiday in Italy. But many people protested and thought The Town Hall not sufficiently impressive or imposing and 'not a public building'. Consequently a much grander Belfast City Hall with a domed roof was opened in 1906 at Donegall Square. The Town Hall building was used as the Family and Coroners Court for many years but has recently closed.

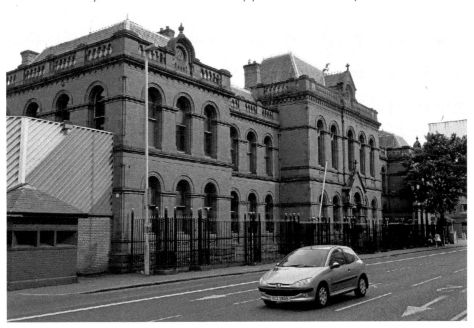

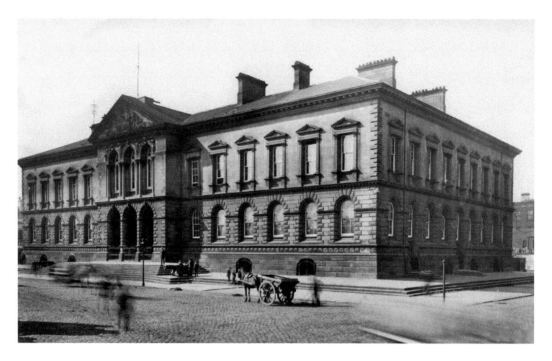

Custom House

Once described as 'Belfast's finest public building', the Custom House was completed in 1857. In this 1928 view from Donegall Quay a close look will reveal a cannon beside the front door which was captured from the Russians in the Crimean War. There are elaborate carvings and sculptures in the pediment of this great edifice, and a high point in Belfast as a trading port came in 1905 when only two other ports in the British Isles collected more customs revenue. The other side of The Custom House has a set of steps facing Queen's Square and in bygone days was a venue akin to Speaker's Corner where open-air public meetings were held to discuss important issues such as politics, religion and strike action.

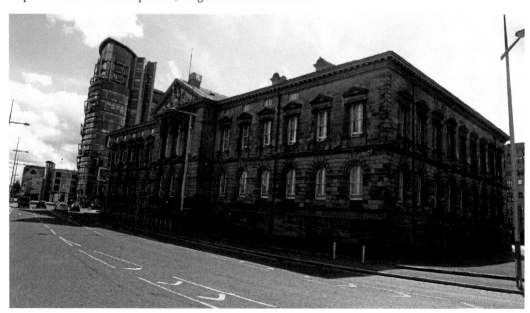

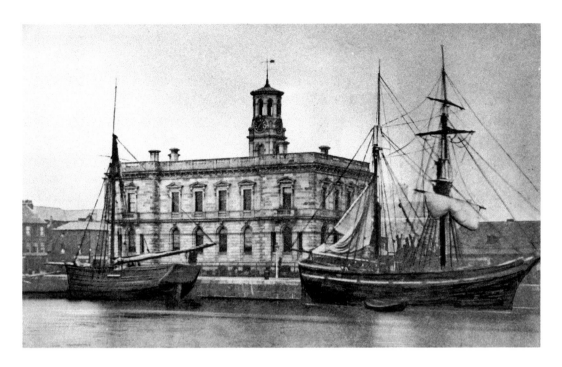

Harbour Office

The 'Ballast Board' was a body constituted in 1785 for the development of Belfast's burgeoning port including new deep-water channels and eventually land reclamation. In 1847 the Belfast Harbour Act brought the Belfast Harbour Commissioners into being and the new Harbour Office (above), designed in the style of a Renaissance Italian palace, was opened in 1854. It has been described as 'one of the most handsome public buildings in Belfast'. The small sailing vessels in this 1890s view from Queen's Quay look like either schooners or brigantines, which could well be colliers bringing supplies of coal from Cumbrian or Welsh coalfields.

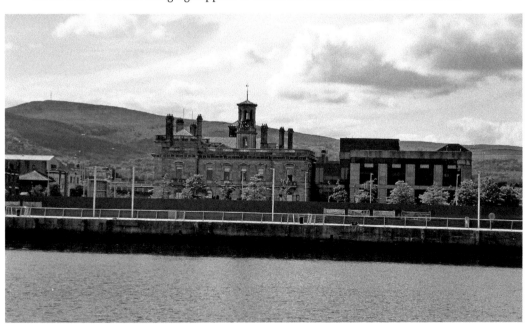

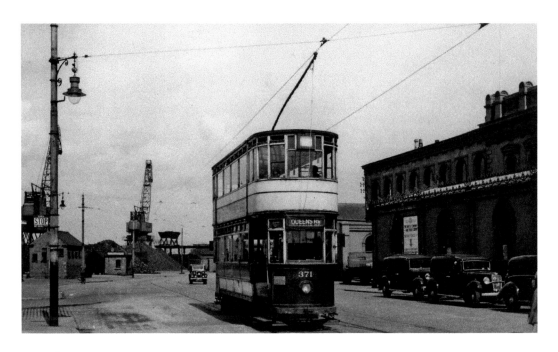

Queen's Quay

Across the River Lagan facing the Harbour Office in the 1950s was the BCDR terminus building (right) and a 'Chamberlain' tram is heading along Station Road en route to Queen's Road. In the background are the coal yards where merchants handled imported coal from Great Britain. Coal was big business and as well as being used for heating homes and public buildings, it powered ships, railways and factories. The BCDR station was one of three railway termini in Belfast and all have been demolished in recent years in addition to the coal yards. The Odyssey entertainment complex was opened on this site in 2001 and consists of several venues including the Odyssey Pavilion SSE Arena Belfast and W5 in an area now known as Titanic Quarter.

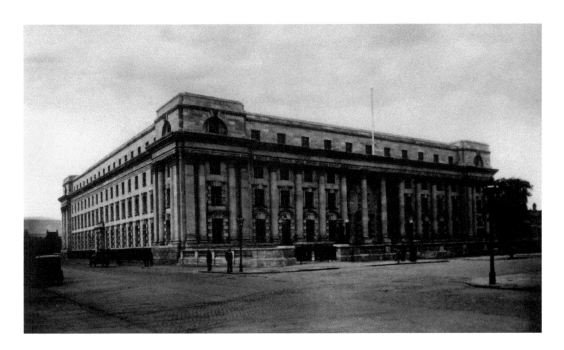

Royal Courts of Justice

Most of the buildings on Oxford Street are modern as this part of Belfast extending as far as the Markets and Cromac Street has been redeveloped in recent years. An exception is 'The Royal Courts of Justice', which was built in 1933 and finished in Portland stone with Corinthian columns and has been described as an 'architectural monument of consequence'. Opened in 2002, the neighbouring Laganside Courts complex was designed to replace facilities at Newtownabbey Courthouse, Belfast Magistrates' Court and the Crumlin Road Courthouse thus making Oxford Street a central hub of the local justice system.

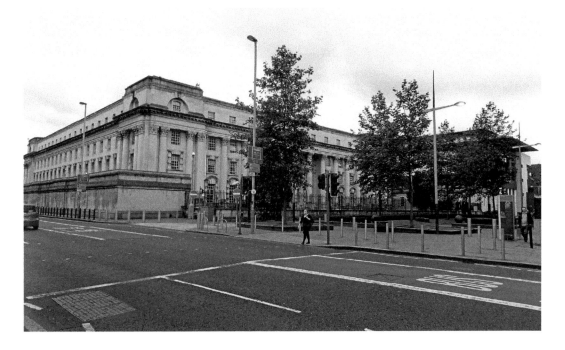

Cromac Street

Cromac Street was laid out in the 1860s to connect central Belfast with Ormeau. At Nos 1 and 3 Cromac Street were the premises of Wilson & Strain Ltd, 'Bakers and Confectioners, Wholesale and Retail Flour Merchants'. The business was established in the 1870s and Mr Wilson later left to establish the 'Ormo Bakery' on Ormeau Road. Mr Strain continued to operate the bakery until he retired in the 1890s and then became involved in property development. By the early 1900s Wilson & Strain (*above*) had ceased trading and the building was then occupied by Ulster Bank before demolition and rebuilding as the much grander Post Office Telephone House, which was opened in 1931.

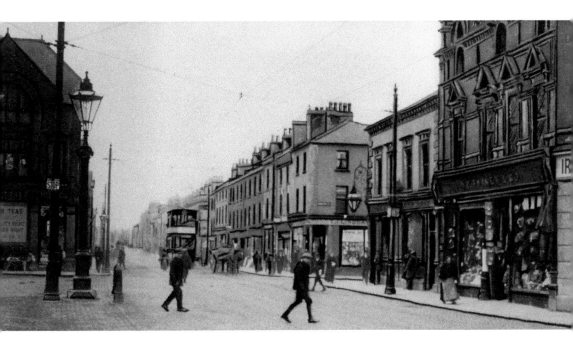

Cromac Square

Cromac Square was a bustling area of the markets in the early 1900s. At No. 33 Cromac Street (*right*) was the premises of W. G. Twinem, outfitter and milliner. The tram in the distance is travelling from Ormeau Road into Belfast. Henry Joy explained that the Earl of Donegall had extended the gardens of Belfast Castle in the late 1600s, laid out extensive pleasure grounds through the woods of Cromac (Irish: 'bending river') and diverted the course of the Blackstaff River into Cromac Dock at the River Lagan. Cromac Street was also the site of the Cromac springs which once supplied fresh water for the neighbouring McConnell's brewery and their Cromac distillery. The Cromac Woods have been built over, Cromac Square no longer exists, the distillery is closed and all the buildings in sight have been demolished.

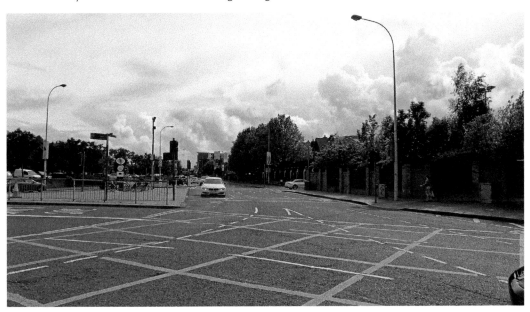

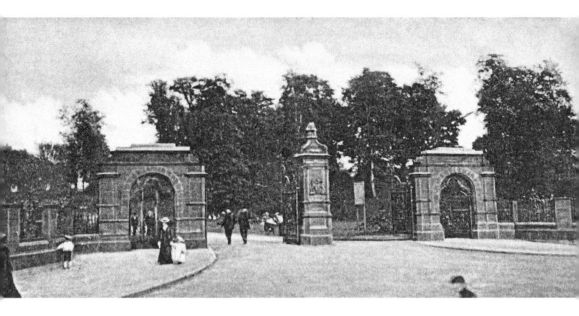

Ormeau Park

In 1807 the 2nd Marquis of Donegall moved into a house called Ormeau Cottage in the townland of Ballynafeigh, not far from the Ormeau Bridge (built in 1815.) The Donegalls had hit hard times and after selling leases on their Belfast lands were able to build the mock-Tudor Ormeau House (described as 'an ill-constructed residence') in the 1820s. The name Ormeau is derived from French and means elms by the water (orme:elm and eau:water). By the 1860s the house was abandoned and demolished and by 1871 the 175-acre estate was acquired by Belfast Corporation as its first municipal park. In the 1890s part of the estate was sold for building sites around North Road and in 1893 Ormeau Golf Club was formed – one of the oldest in Ireland. Although the house is gone, the gates survive.

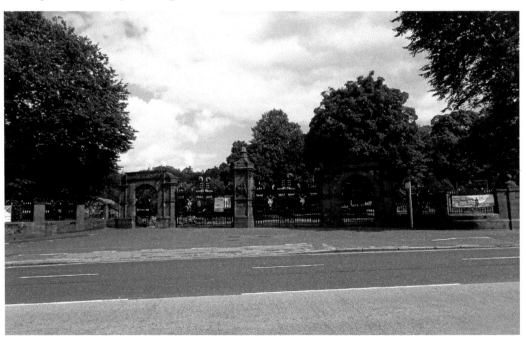

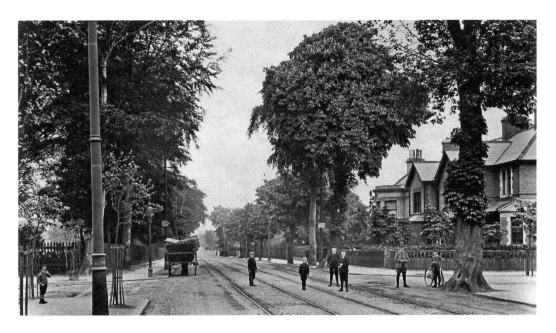

Ravenhill Road

During Victorian times the Old Ballynafoy (or Ballynafeigh) Road connected Lagan Village with Rosetta and it is known today as the Ravenhill Road (which was named after a large house in the area). The modern Ormeau Road runs parallel to the Ravenhill Road and was originally called the New Ballynafoy Road. The tramway system connected this suburb with Belfast around 1900. There is not much traffic on the road, shown by this group of boys having gathered to look at the photographer in this early 1900s view of the junction at North Road and Ravenhill Park. Ormeau Park Golf Club is to the left in a portion of the old Ormeau estate, and the home of Ulster rugby, Ravenhill stadium (now known as Kingspan) is to the right.

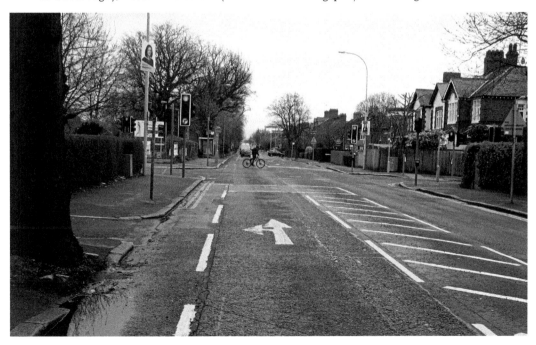

5. Central Belfast ,Wellington Place, Shaftesbury Square

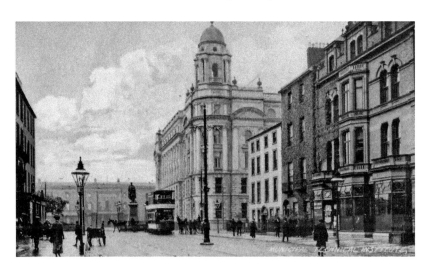

Wellington Place

The Municipal Technical Institute was opened in 1907 at College Square North and was known for many years in Belfast as 'The Tech' and more recently as part of Belfast Metropolitan College. It was built during the industrial boom time for Belfast when it was known as a world-leading industrial centre for its shipyards, rope-works, engineering factories and linen mills and closed in 2013. Legislation was passed which established technical schools, and Belfast Corporation met with the local industrial chiefs to discuss technical training. Land was acquired from the neighbouring Royal Belfast Academical Institution, known as 'Inst' (in the background above), who were in some debt at the time. The Tech was built in College Square, known then as the 'Harley Street' of Belfast. The statue of the Revd Henry Cooke, the 'Black Man' (which is actually green), stands alongside The Tech and looks along Wellington Place towards Belfast City Hall.

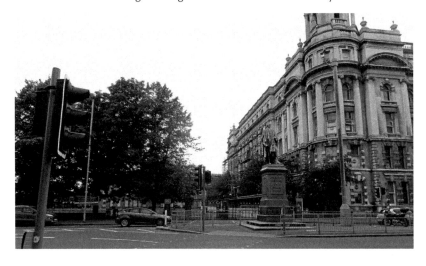

Presbyterian Assembly Buildings
Church House is located at
Fisherwick Place, which is a
continuation of College Square
East. It is home to the General
Assembly, or headquarters, of the
Presbyterian Church in Ireland.
Church House was built in 1905
on the site of Fisherwick Place
Presbyterian Church (which moved
to a new location on Malone Road
and retained the name.). It was
built in Gothic style and opened by
the Duke of Argyll. Church House
is dominated by a 40-metre-high
clock tower, which contains
Belfast's only peal of twelve
bells. Church House, or Assembly
Buildings, was refurbished in 1992
and now provides retail space
known as 'Spires Mall' on the
ground floor. The grand Main Hall
is used as a conference venue.

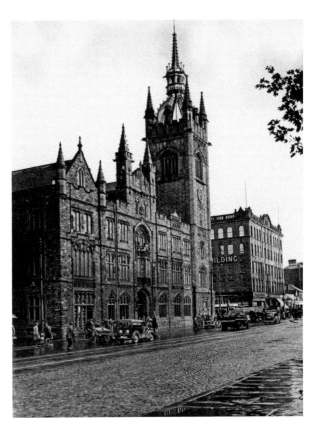

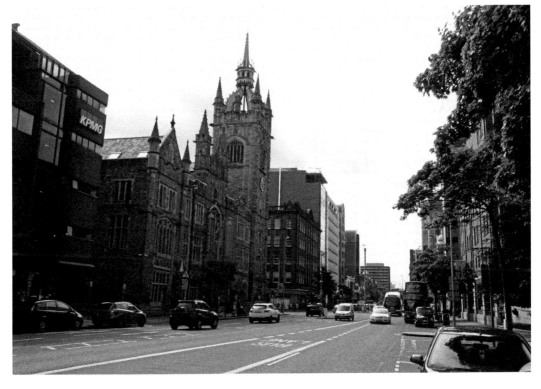

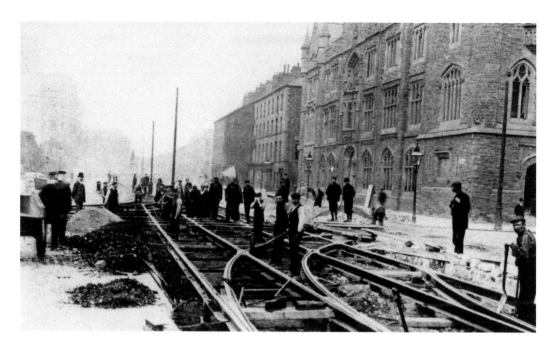

College Square

Prior to 1872, public transport in Belfast was supplied by a horse-drawn bus service. In that year the Belfast Street Tramways Co. introduced a single-deck horse-drawn route and the first line travelled from Castle Place to University Road via College Square. The tramway system was a great success and by the 1890s included a fleet of over 100 trams, pulled by nearly 1,000 horses and carrying around 11,000,000 passengers annually. The world's first electrically powered tramway was opened at the Giant's Causeway on the Antrim coast in 1883. Belfast Corporation electrified their system in 1905, at which time much of the track network was improved (above) and expanded. But the official 'Last Tram Procession' took place in 1954 when during commemorations, attended by civic dignitaries, special tickets were issued to mark the occasion.

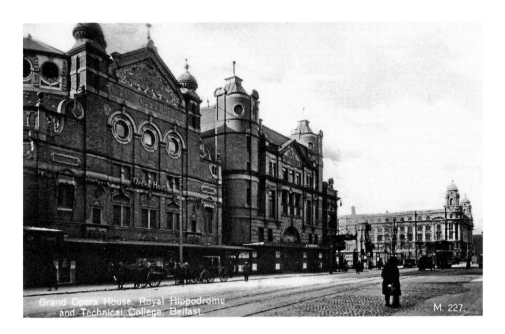

Grand Opera House, Royal Hippodrome and Technical College, Belfast.

M. 227.

Grand Opera House

The wonderful Grand Opera House (*left*) was designed by leading English theatre architect Frank Matcham and opened in 1895 in Great Victoria Street, near the Grosvenor Road junction at what was then a desirable residential location. It was described at the time as a 'perfect Eastern palace'. In view alongside the Grand Opera House are the Hippodrome cinema and in the distance the Municipal Technical Institute, which were both built in 1907. In between, the huge Ritz cinema (now the site of Jury's Hotel) was opened in 1936 when Gracie Fields took part in the opening ceremony. The tower-like small building on the future site of the Ritz is part of the helter-skelter attraction at the fairground held here for many years.

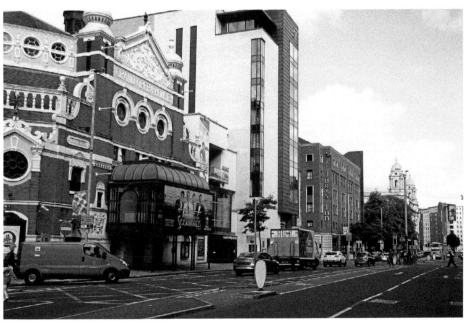

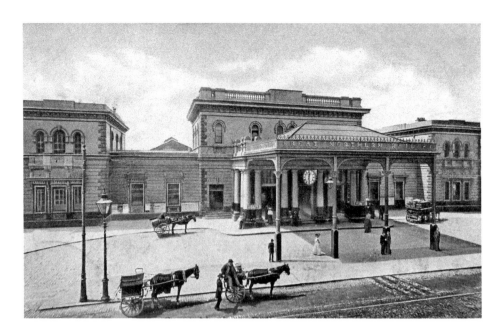

Great Northern Railway Station

The three railway terminus buildings in Belfast from Victorian times until the 1970s included the Belfast & County Down Railway at Queen's Quay (BCDR), The Northern Counties Committee (NCC) or L.M.S. on York Street and the Great Northern Railway (GNR) on Great Victoria Street. The GNR was originally known as the Ulster railway and heralded the first railway line in Belfast, which travelled 7 ½ miles to Lisburn in 1837. The Great Northern Railway station was opened in 1848 and its imposing façade (*above*) containing twelve Doric columns, has been described as 'pompous'. In 1971 it was replaced by the Europa Hotel which was known as 'Europe's most bombed hotel'.

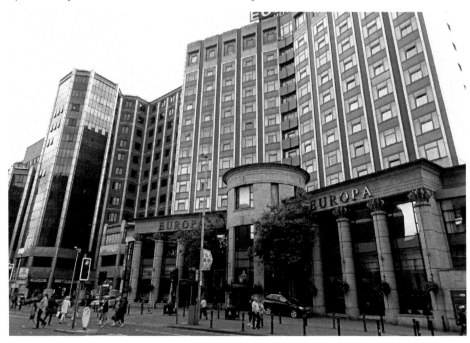

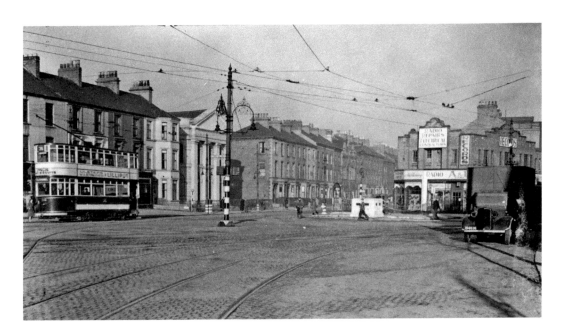

Shaftesbury Square

The 8th Earl of Shaftesbury married Lady Harriet Chichester on 22 August 1857. She was the only daughter of George Chichester, 3rd Marquis of Donegall, whose family had founded Belfast in the 1600s and this happy event apparently restored the Donegall family fortunes. This was a residential area at the junction of Great Victoria Street and Dublin Road, and in the 1870s the houses had front gardens with railings, although today it is mostly restaurants and offices. The white building on the corner (*below*) is the Ulster Bank which was built in 1960, on the site of the former Magdalen House School, and created a stir when it commissioned two untitled cast, aluminium works of public art that look like human figures, for the corner façade of its building. With typical Belfast humour the statues were dubbed 'Draft' and 'Overdraft'.

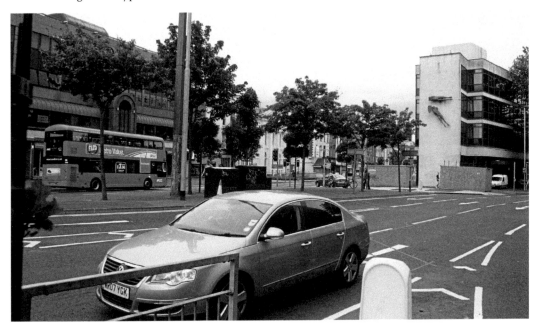

Donegall Pass

A pass or passage was developed here in the Cromac Woods in the 1600s and now connects the modern Ormeau Road with Shaftesbury Square. The historic association, with its wooded past, survives in local street names such as Elm Street, Oak Street and Walnut Street. This wooded locality maintained its countryside presence until as recently as the late 1700s when 'rural retreats' were developed. Residential development commenced in the 1830s and No. 62 was the home of Mary Ann McCracken, sister of United Irishman Henry Joy McCracken. In the background, at the Ormeau end of Donegall Pass in this 1940s view (*above*) is the gasworks and the large building to the left is the RUC Barracks, which is now the more heavily fortified (*below left*) PSNI station.

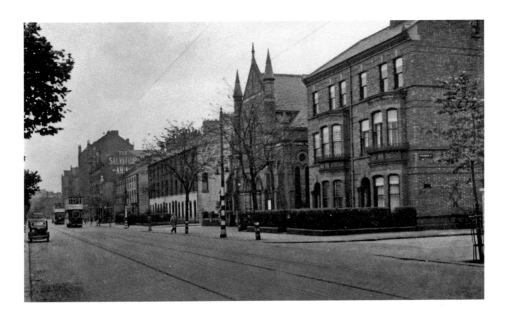

Dublin Road

In the centre of this 1940s view of Dublin Road, the building with the fine pinnacles is Shaftesbury Square Reformed Presbyterian Church (originally Dublin Road Reformed Presbyterian Church), which was constructed in 1889. Note the approaching trams, which caused something of a nuisance for church-goers in the early 1900s as they rumbled loudly past on Sunday mornings. The Dublin Road was laid out in the early 1800s to replace the old route to Dublin from Belfast, which travelled via Sandy Row, and it crosses the River Blackstaff, one of many small rivers that flow through the city to the River Lagan. By 2015 many of the old houses had been replaced by modern buildings and the blue-fronted office (*below*) on the corner of Pakenham Street is the headquarters of the European Commission in Northern Ireland.

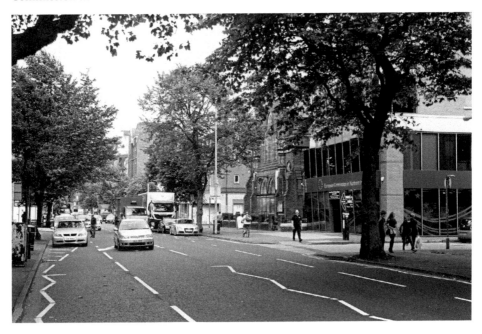

6. South Belfast , Shaftesbury Square, Stranmillis, Balmoral, Malone, Shaw's Bridge

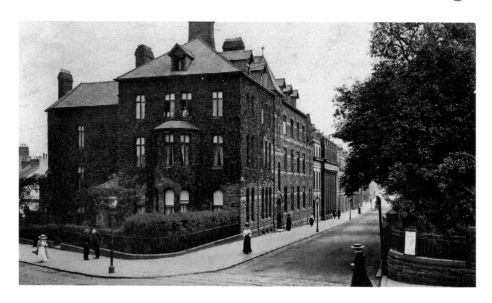

Crescent Arts Centre

Upper and Lower Crescents were completed with grand housing in the 1850s containing what has been described as 'highly imposing stucco terraces in the Bath manner'. At No. 1 University Road (below), on the corner of Lower Crescent, stands the present Crescent Arts Centre, which during major renovations was awarded the UK 'Man and the Biosphere' Urban Wildlife Award for Excellence in 2010 for preserving the 136-year-old breeding colony for threatened swifts. This was the home of Victoria College, Belfast's premier girls' grammar school which was founded as the Ladies Collegiate by Mrs Margaret Byers at Wellington Place in 1859, moved to Lower Crescent in 1873 and Cranmore in the 1970s. Queen Victoria graciously granted the royal title in 1870.

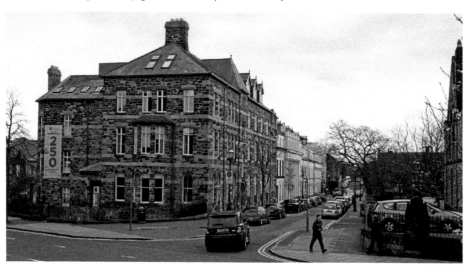

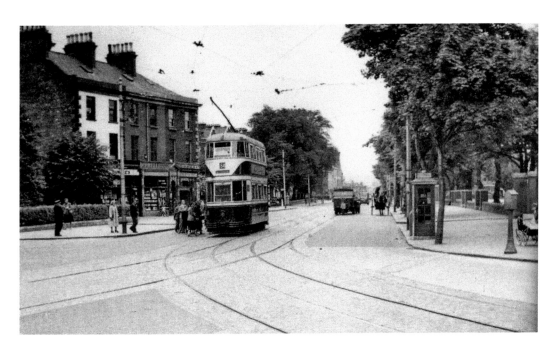

University Road

Queen's University is just out of sight to the right in this 1950s view containing a McCreary tram collecting passengers travelling towards Belfast. The university is the most important custodian of listed buildings in Northern Ireland, after the National Trust, and the University estate contains more than 250 premises. The modern building (*below left*) which has replaced the terraced housing is owned by Ulster Bank. In the distance the modern Queen's University Students' Union was built in 1965 on the site of a grand 1850s Jacobethan terrace called 'Queen's Elms'. The terrace was surrounded by elm trees, though these were cut down after an outbreak of Dutch elm disease.

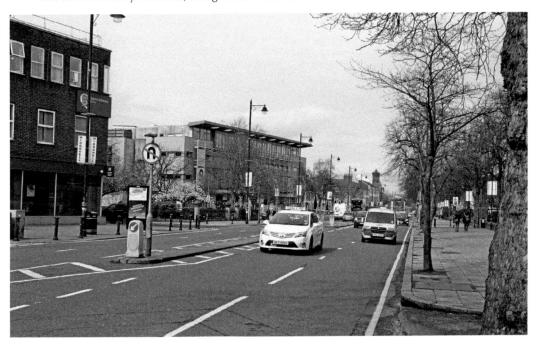

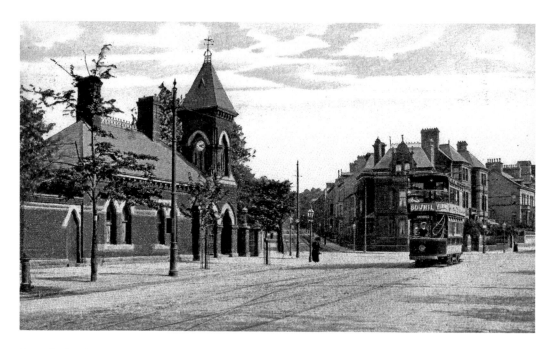

Botanic Gardens Entrance

The ornate Venetian Gothic-style gate lodge with clock tower was designed by architect William Batt in the 1870s and built in a mixture of brick and stone. It stood at the entrance to Botanic Gardens, but was 'wantonly demolished' in 1965 so that the site now seems rather empty. The large house behind the tram was built in 1889 and is remarkably unchanged, standing at the junction of University, Stranmillis and Malone Roads. The electric tram is an early model that included an upstairs roof to protect passengers from the weather, and the young trees at the roadside have grown considerably over the past 100 years.

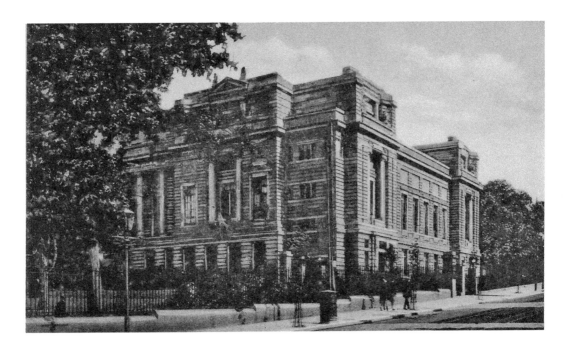

Ulster Museum

The Belfast Natural History and Philosophical Society was founded in 1821 and in 1830 the enthusiastic membership built a new museum in the fashionable area of the growing town at College Square North, overlooking Inst school. In those self-reliant times the museum was the first in Ireland to be built by voluntary subscriptions. In 1929 it moved to its present location (*above*) on Stranmillis Road. A major extension to the original museum building was completed in a modern style in 1964 and described as a 'deft union of two diametrically opposed building styles'. A more recent renovation was completed in 2009 and the museum reopened on its eightieth anniversary.

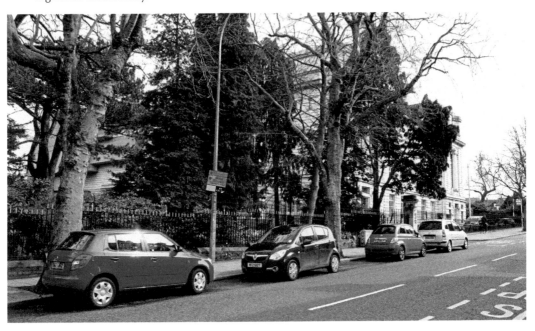

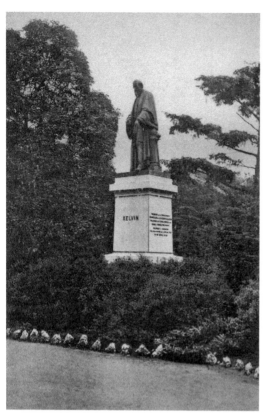

Kelvin Statue, Botanic Gardens

William Thomson was born at College Square East in 1824. His father James was a mathematics teacher at the Royal Belfast Academical Institution and had a short walk to work as Inst was directly across the road from their home, the site of which was to be occupied in 1910 by the Kelvin Picture Palace cinema. The Thomson family moved to Glasgow in 1833 and William studied physics at Glasgow University. He was knighted in 1866 and became Lord Kelvin in 1892 for his groundbreaking work on thermodynamics and electricity. The title derives from the River Kelvin which runs by the grounds of the University of Glasgow. When he retired he had more academic honours after his name than any man alive. He died in 1907 and was buried in Westminster Abbey. The statue close to the Ulster Museum at the entrance to Botanic Gardens was erected on a wet day in a grand unveiling ceremony in 1913.

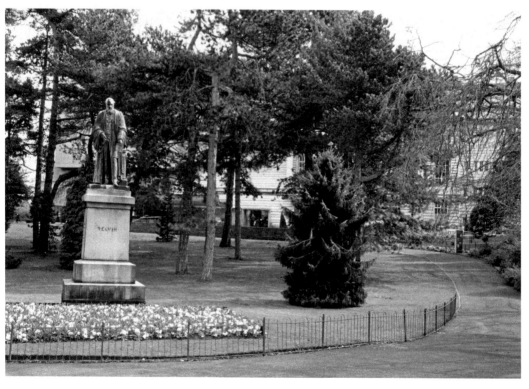

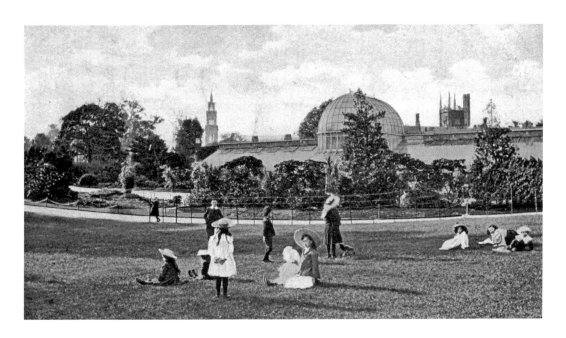

Palm House, Botanic Gardens

The Belfast Botanical and Horticultural Society established the Botanic Gardens as a private concern entirely from public subscriptions in 1828. The Marquis of Donegall laid the foundation stone for the curvilinear glass and iron Palm House (pictured) in 1839 and this was followed in 1889 by a new Tropical Ravine building containing a fernery, with a sunken glen and a waterfall. The gardens held many social activities during Victorian times including band concerts, military tournaments, dog shows and tightrope walking. After many years of financial uncertainty The Royal Belfast Botanic Horticultural Company Limited sold the gardens to Belfast Corporation in 1895 when they were opened free of charge to the general public and became Belfast's sixth public park. The Botanic Gardens continues to be frequented by residents, students and tourists and is an important venue for concerts, festivals and other events.

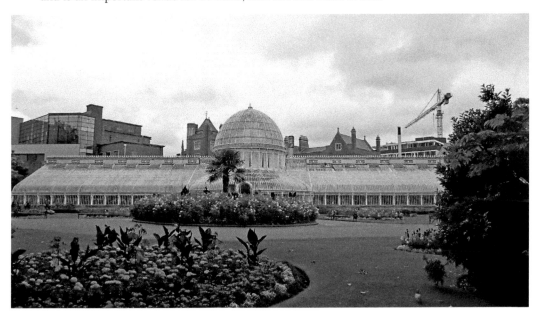

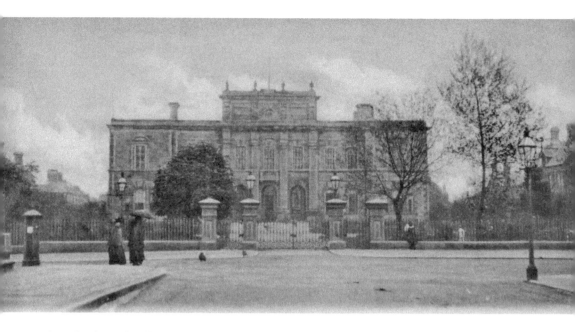

Union Theological College

The architect of Assembly's College on Botanic Avenue (above) was Charles Lanyon and it was founded in 1853 by the General Assembly of the Presbyterian Church in Ireland to provide training for Presbyterian ministers. At the façade of the building is a grand Doric porch in rusticated stonework once described as 'the finest architectural edifice in Belfast'. From 1921 until 1932 the newly formed Parliament of Northern Ireland met in Assembly's College while awaiting the construction of the new Parliament Buildings at Stormont. From 1941–48 it was occupied by the Royal Ulster Constabulary whose Belfast headquarters had been destroyed in the Blitz. In 1978 Magee College in Londonderry closed and the two colleges amalgamated under the new name of Union Theological College.

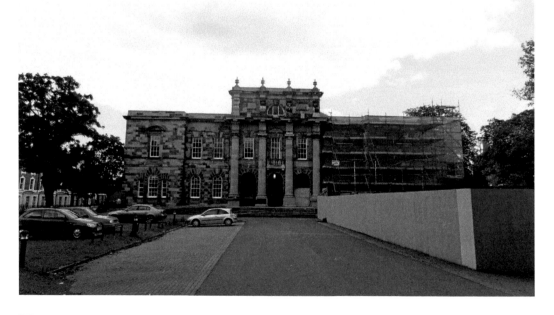

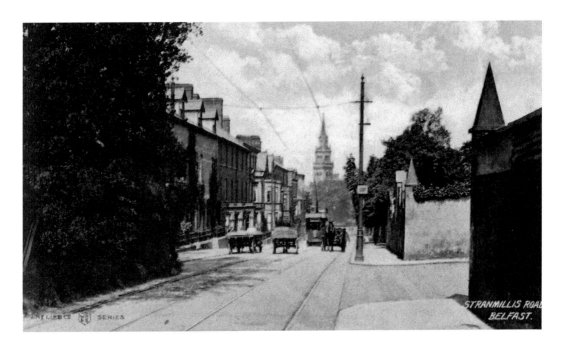

Friar's Bush Graveyard

In the distance is the towering 'wedding cake' presence of Elmwood Presbyterian Church (now Elmwood Hall). The open-topped 'Standard Red' tram on the Stranmillis Road indicates a date before 1907. The oldest burial ground in Belfast is Friar's Bush which is immediately to the right and was once the site of a Franciscan monastery. Its origins may be pre-Christian with associations to St Patrick and it was the main Catholic burial ground in Belfast until 1869 when Milltown Cemetery was opened on Falls Road. In 1928 the Marquis of Donegall provided extra land for an extension to the Friar's Bush site and an 8-foot-high wall was erected to deter bodysnatchers. The smart terraced housing on the left was built between 1870 and 1890 and the Conor Café, facing the Ulster Museum, was once the studio of leading Ulster artist William Conor.

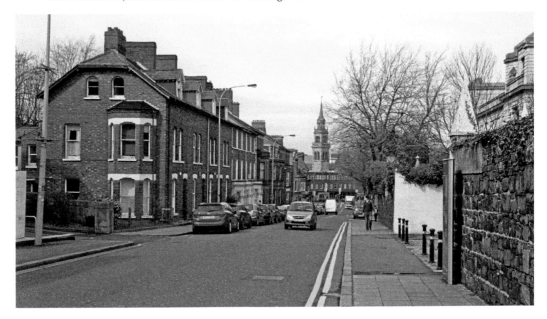

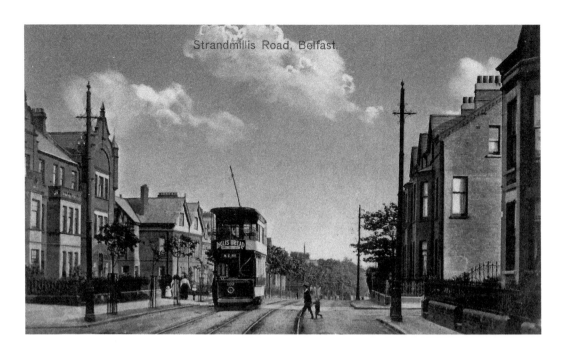

Strandmillis Road, Belfast.

Stranmillis Road

The name of Stranmillis is taken from the Irish Sruthan Milis – 'the sweet stream'. Not far away is the point at which the fresh (or sweet) water from the River Lagan meets the salty tidal flow. By the late Victorian period much of the front of Stranmillis Road (*above*) had taken shape and is remarkably unchanged in 2016. On the lower portion of the road are two monumental University facilities: The David Keir Building was opened in 1959 as part of a post-Second World War expansion programme and described as 'the greatest addition to the University property in its history'. The Ashby Institute was opened in 1964 and although it has created some open spaces in its grounds, it has been described as 'impersonal and disturbing in scale'.

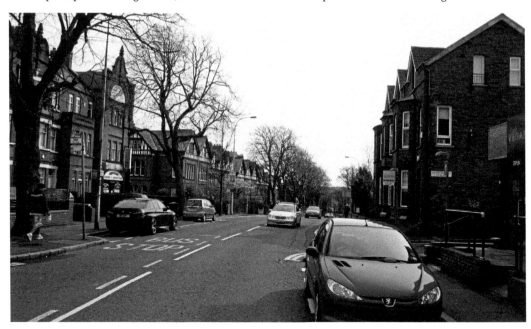

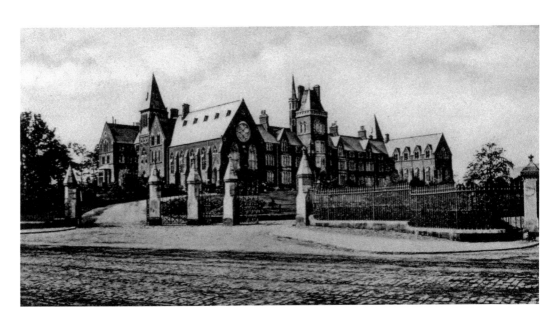

Methodist College

There were originally plans to build a Church of Ireland cathedral on this site at 1 Malone Road not far from Queen's College back in 1868. In the event a Wesleyan Methodist Collegiate school was established instead (*above*) with a view to the dual purpose of training candidates for the Methodist ministry as well as a general education. It became known as Methodist College in 1885. The grand school buildings were designed in the English Gothic and other historic styles. The imposing gateposts to Methodist College, those adjoining College Gardens plus the large house to the far right, have all gone, as have the square-sets and tramlines on the road surface.

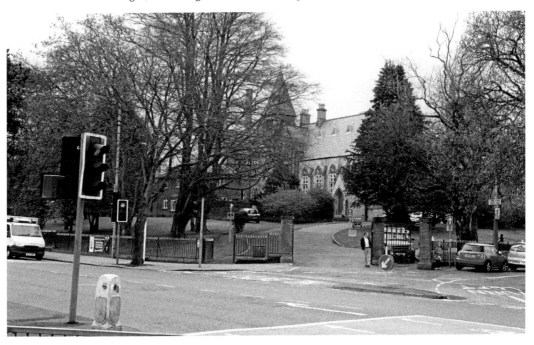

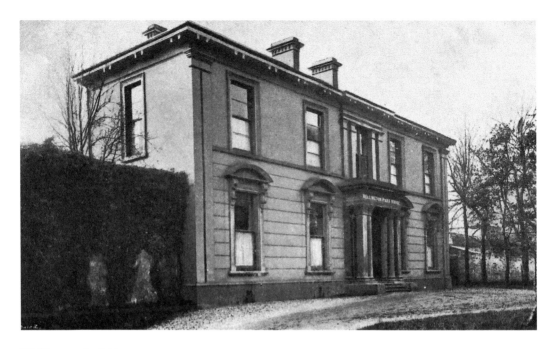

Wellington Park House

The modern Wellington Park Hotel at No. 21 Malone Road (*below*) was built on the site of a grand detached residence. The house was constructed during the 1860s at a time when Belfast was rapidly expanding and was fairly typical of the 'plump and prosperous villas' taking shape in the more exclusive areas of the town. The first resident of Wellington Park House was George Tate who is described as a 'gentleman'. He was a wealthy timber merchant with premises at No. 86 Tomb Street, Belfast. By 1901 the house was occupied as 'Salvation Army Women's Industrial Home' by the government during the Second Wolrd War and then in the 1950s Wellington Park Hotel, although the old building (*above*) has been substantially rebuilt in recent years.

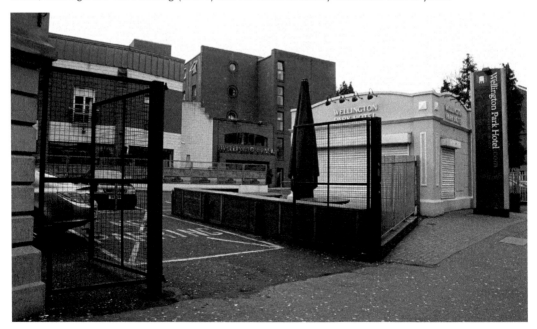

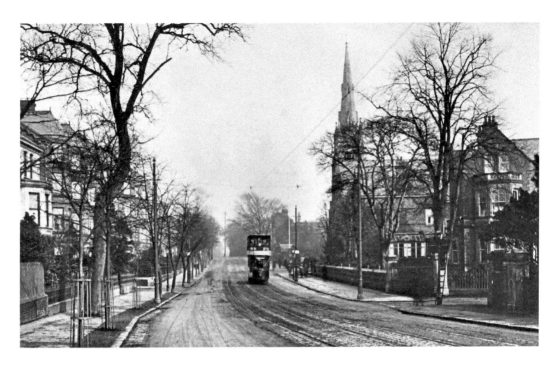

Fisherwick Presbyterian Church

The original Fisherwick Place Presbyterian Church was opened in 1827 on the site of the present Assembly Buildings. The congregation moved to the present church building at No. 4 Chlorine Gardens (*above*) in 1901 and retained the Fisherwick name. The architect was Samuel Close who had designed many Church of Ireland churches and the style of this fine neo-Gothic edifice reflects that heritage. Travelling along Malone Road the land rises to higher levels from the lower ground of old Belfast town and this transition was once described as 'from slobland to snobland'.

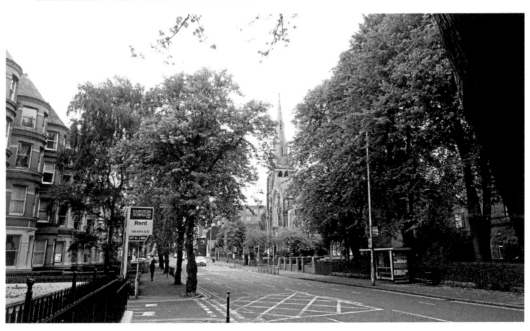

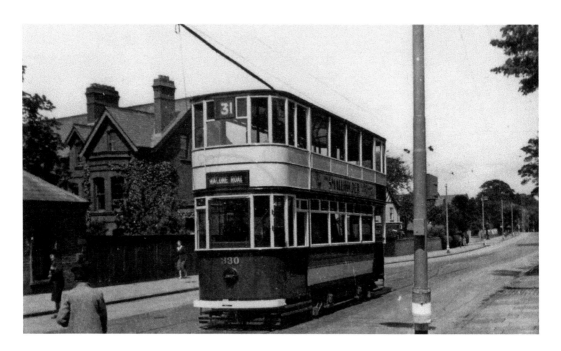

Malone Road

The Malone Road (Irish: Maigh Lón, meaning 'plain of lambs') leads from the university quarter southwards to the affluent suburbs of Malone and Upper Malone. The road is built on a raised glacial feature called the 'Malone Ridge'. This residential area in the airy and leafy suburbs of South Belfast has become synonymous with affluence. The Moffett tram (*above*) is decked out in wartime livery, including a leading-edge luminous strip, so this suggests a 1940s view. The tram is stopped at the end-of-lines alongside the gate lodge to the exclusive Malone Park and ready for the return journey to the city.

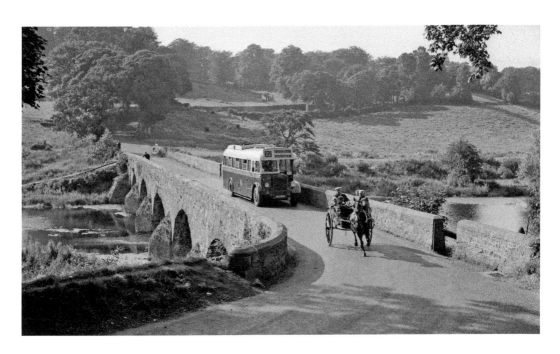

Shaw's Bridge

Shaw's Bridge is a solid five-arch stone structure which spans the River Lagan, as in this summer scene from 1952. It has been a crossing point since Stone Age times and the first wooden bridge was constructed here in 1617. In 1655 a Capt. Shaw, a member of Oliver Cromwell's army, built a stronger wooden bridge capable of carrying heavy siege artillery but this was washed away in a storm and a five-arched stone bridge replaced it in 1709. The narrow road leading to Shaw's Bridge was widened in 1975 to accommodate ever increasing volumes of road traffic and a new bridge was constructed. The old bridge has been retained and is now part of a pedestrian area in the picturesque 4,000 acre Lagan Valley Regional Park.

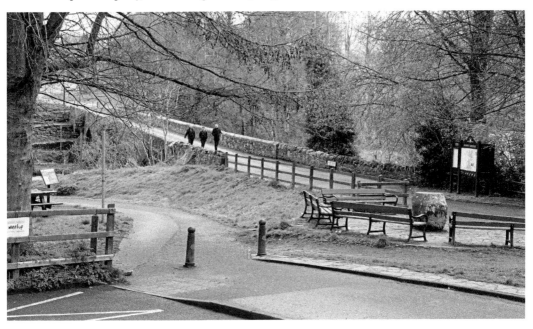

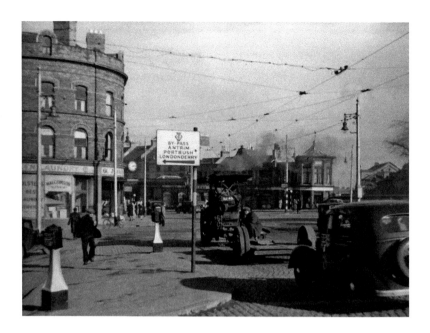

Sandy Row

There aren't many steam traction engines on the roads today like the one in this 1949 view. Sandy Row is on the left and it is a long established area which in 1780 was described as a 'long string of falling cabins and tattered houses'. It travels from the Grosvenor Road to the Lisburn Road (*above*). Local folklore provides a couple of reasons for the name. One was that a local landlord Alexander (Sandy) Frazer built a row of houses there in the 1700s. Alternatively it may derive from sandbanks formed by the presence of the nearby Blackstaff River. Just facing Sandy Row on Lisburn Road is King William Park which was given that name officially in 1964. Tradition has it that King William of Orange stopped here in 1690 as he marched his army south to meet King James II at the Battle of the Boyne.

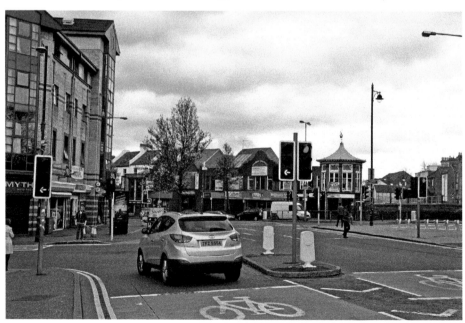

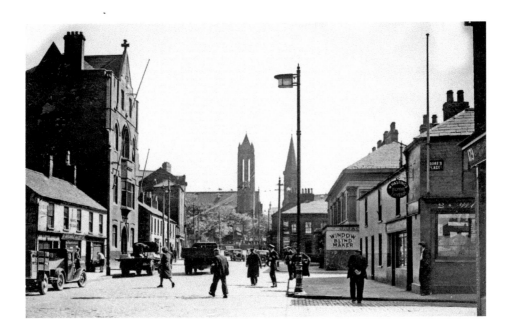

Sandy Row to Lisburn Road

There are three large buildings commanding this 1940s view of Sandy Row looking in the Lisburn Road direction. On the left is the Orange Hall, which was opened in 1910 and is said to be on built on a site where King William's troops camped on their way south in 1690. The distinctive campanile belongs to Crescent Presbyterian Church (1887). The congregation amalgamated with neighbouring Fitzroy Presbyterian Church in 1976 and it is now a Brethern Church. The smaller tower belongs to the Moravian Church (1887). An ancient Protestant Episcopal denomination which originated in the Czech homeland of Bohemia, the Moravians came to Great Britain in the 1700s. Tall modern buildings now overwhelm this area.

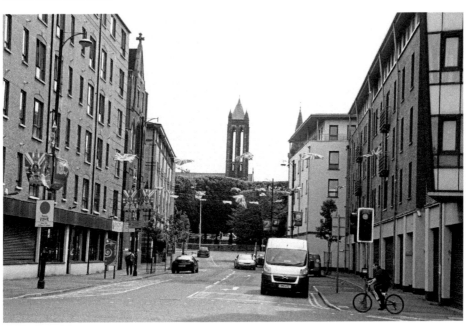

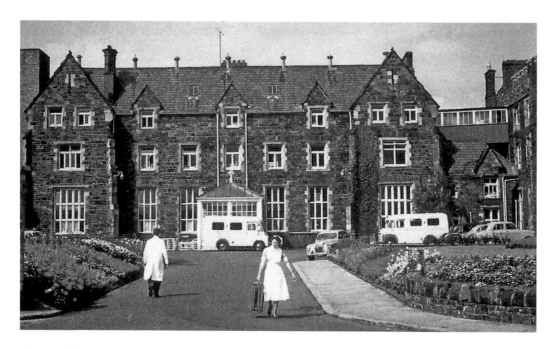

The Workhouse

Following a number of fever epidemics in the 1830s, the Irish Poor Relief Act of 1838 established the Belfast Union Workhouse (once described as 'gloomy') on the Lisburn Road, with room for 1,000 people (*above*). The Belfast Union Fever Hospital was added in 1865. When the Poor Law system was closed down in 1948 these buildings came under the auspices of the Hospital Authority and were demolished to accommodate the site of the new Belfast City Hospital tower block (*below*) in 1984. However, one of the original gateposts to the workhouse has been retained and can be seen facing the Claremont Street entrance on Lisburn Road.

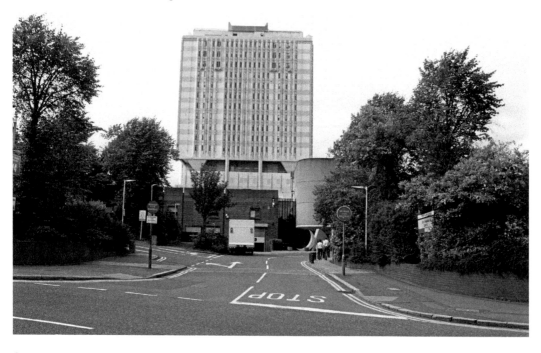

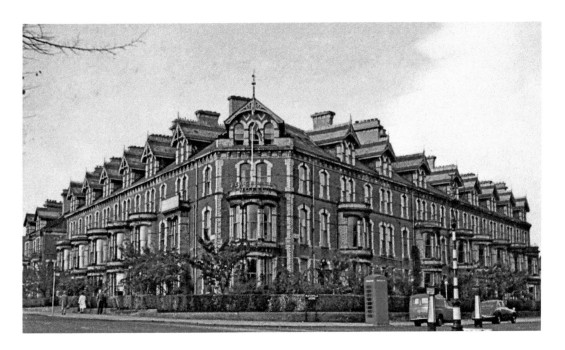

Belgravia

When the large terraced development of 'Belgravia', on the corner of Ulsterville Avenue and Lisburn Road, was constructed in the late 1870s the occupants represented a cross-section of the burgeoning middle classes in late Victorian Belfast. Worthy occupants included doctors, railway managers, grain merchants, flour merchants, linen merchants, fireclay and alabaster merchants and a missionary. By the 1940s it is described as Belgravia Hotel and by the 1950s Belgravia Private Hotel, which became a residential hostel for elderly people run by the Northern Ireland Housing Association. A terrorist bomb destroyed this lovely old building in early 1980s and the Belgravia was totally rebuilt in 1985 to contain sheltered and retirement housing.

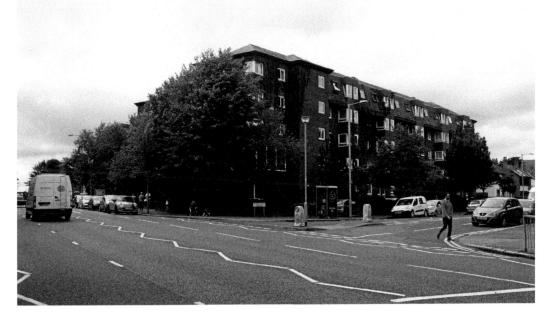

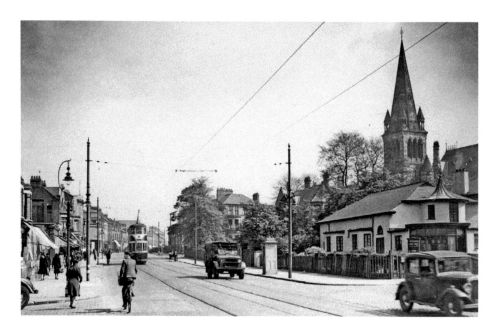

St Thomas' Church

Located on the corner of Eglantine Avenue and Lisburn Road, St Thomas' Church of Ireland was designed on a grand scale by leading architect Charles Lanyon. He was also responsible for the design of several landmark buildings around the city including Queen's College and Belfast Castle. When St Thomas' was consecrated in 1870 this location (above) was in a fashionable suburb right on the edge of town where there was little Church of Ireland presence. The military vehicle approaching Malone Avenue in this 1946 view is alongside a grey K3 telephone kiosk and the low-rise building on the right-hand corner is 'Windsor School of Dancing'; an elderly neighbour once told me that he had once danced here with the sister of Hollywood film star Errol Flynn. This site is now occupied by the rather more imposing offices of a firm of estate agents.

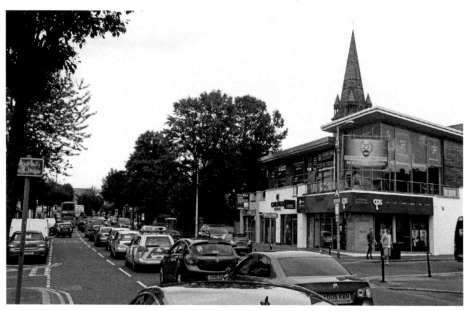

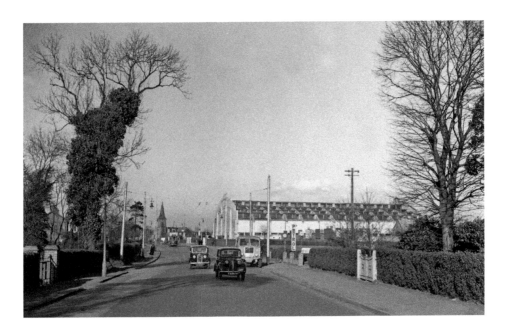

Balmoral

The Royal Ulster Agricultural Society had been based at the Markets in Belfast and in 1896 moved to a new 32-acre site at Balmoral. The King's Hall became the centrepiece building of the complex and it dominates this 1940s view of Balmoral. It was built in 1934 and was opened by the Duke of Gloucester. For many years it was Northern Ireland's largest exhibition centre and concert venue until the more recent opening of the Odyssey and the Waterfront Hall. It closed in 2012, at which time the Balmoral Show moved to a new site at the former Maze prison near Lisburn. There have been recent newspaper reports that the King's Hall is to be redeveloped and some suggestions include healthcare facilities, a hotel, offices or business space. The spire of Malone Presbyterian Church at the corner of Balmoral Avenue peeps out in the distance in both views.

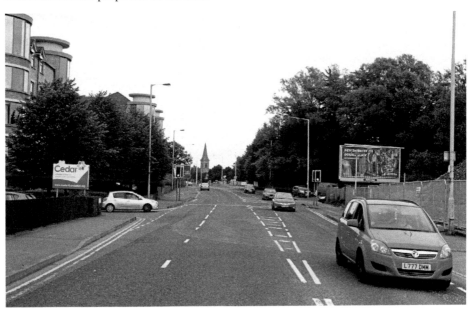

7. North & West Belfast, Shankill, Ardoyne, Cavehill, Glengormley

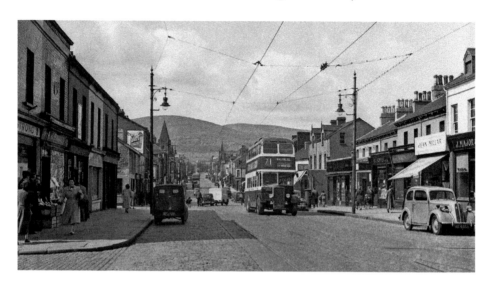

Shankill

The Shankill Road (Irish: Sean Cill meaning 'Old Church') is around 1.5 miles in length and travels from Peter's Hill to the Woodvale Road. Shankill Road was once an ancient track which linked Co Antrim with Co Down and assumed its present name in the 1830s. The Lower Shankill (originally described as Shankhill) has streets named Boundary Street and Townsend Street which marked the outskirts of old Belfast town. The linen industry was a major driving force as Belfast grew during Victorian times and the Greater Shankill area expanded due to the presence of fast-flowing rivers such as the Farset and the Forth, which provided water for steam-powered mills. By the 1960s major industries such as linen, shipbuilding and engineering were in decline. The influence of the 'Troubles' has resulted in unemployment and depopulation.

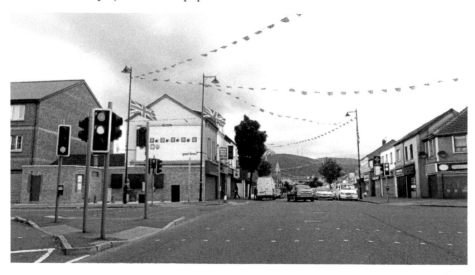

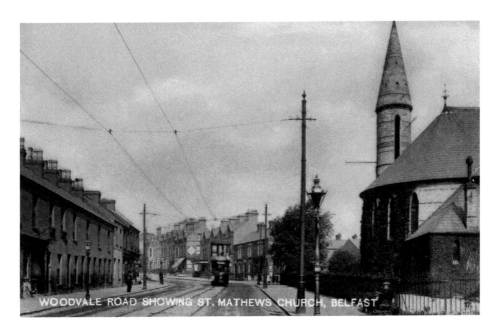

WOODVALE ROAD SHOWING ST. MATHEWS CHURCH, BELFAST

Woodvale

Many of the streets in the Shankill area, such as Leopold Street and Cambrai Street, were named after places and people connected with Belgium or Flanders, where the flax from which linen was woven was grown. The West Belfast Division of the original Ulster Volunteer Force organised in the Shankill area and many of its members saw service in the First World War with the 36th (Ulster) Division. St Matthew's Church of Ireland (above), at the junction of Shankill Road and Woodvale Road, was rebuilt in 1872 and takes its name from the original church which had sat in the grounds of Shankill graveyard and had its last burial in 1934. Bishop MacNiece, of the Church of Ireland, who was the father of local poet Louis MacNiece, once described St Matthews as 'an enlarged shamrock'.

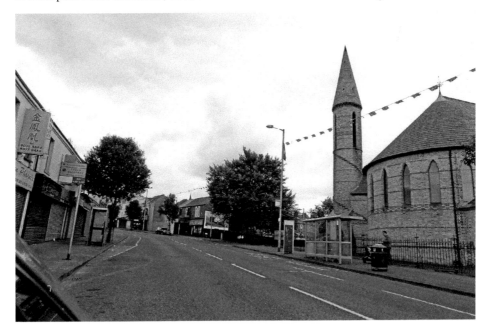

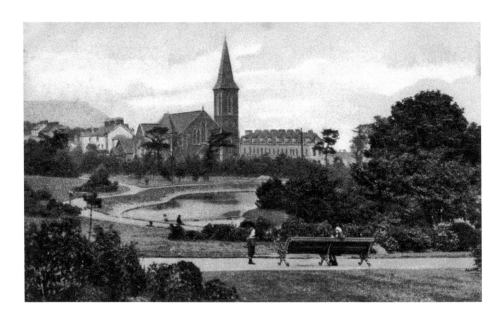

Woodvale Park

From the 1860s a large house called 'Woodville' was located at the top of the Shankhill Road and it was the home of wealthy linen Merchant John Ferguson. He had business premises at No. 31 Linenhall Street, which was then the linen trade commercial centre of Belfast. By the 1880s Woodville was the manse of Revd Samuel McComb, minister of Agnes Street Presbyterian Church. In 1887 Woodville plus 24 acres of ground was purchased by Belfast Corporation to establish Belfast's fourth public park, which became known as 'Woodvale Park'. The handsome tower of Woodvale Presbyterian Church (above) overlooks the park and was built in 1899. The pond was once used during the cold winters for ice-skating, but was filled in and replaced by a children's playground in 1948 due to health and safety concerns and complaints about the aroma emanating from its stagnant water.

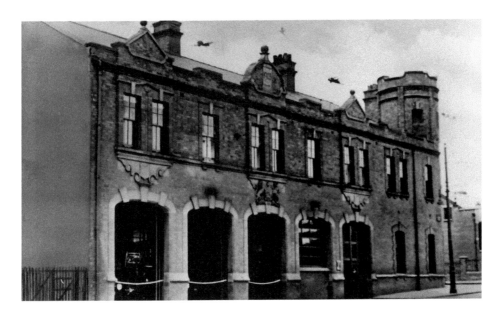

Ardoyne Fire Station

As the suburbs of Belfast continued to expand, several new fire stations were required and in 1904, on Crumlin Road at the junction of Woodvale Road, a new facility was constructed. It was known as the 'Ardoyne Station of Belfast Corporation Fire Brigade' (*above*) and designed in a style of typically Edwardian grandeur. As well as the fire station and offices there was accommodation for fire crews and their families. The Belfast Fire Brigade was formed in 1800 and in 1892 became a fully professional organisation with a new headquarters at Chichester Street in the centre of Belfast in 1894. It amalgamated with the Northern Ireland Fire Service to become the Fire Authority for Northern Ireland in 1973. The old fire station building was demolished a few years ago to be replaced by the more modern 'Ardoyne Ambulance Station'.

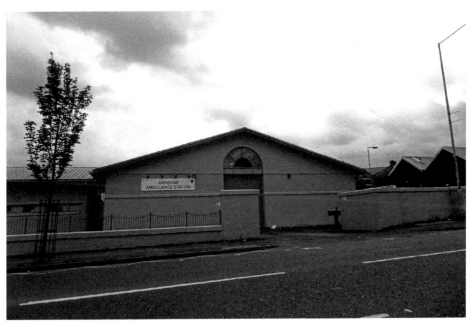

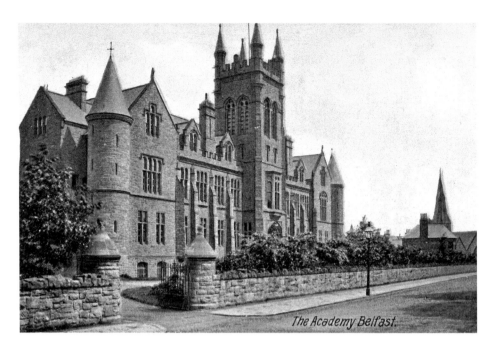

The Academy Belfast.

Cliftonville Road

Belfast Academy was founded in 1785 on a site (now Academy Street) near St Anne's Parish Church and moved to its present location on Cliftonville Road (*above*) in 1880. As the Presbyterian merchant class of Belfast grew in number, the aim of the founders was to provide a place 'where the sons of gentlemen might receive a liberal education'. It has the distinction of being Belfast's oldest surviving school. The prefix 'Royal' was added in 1887 when Queen Victoria granted permission for the school to style itself on Belfast Royal Academy. The architect of the new academy was a former schoolboy called Robert Young, and his Scottish family origins may well have influenced its Scottish Baronial style.

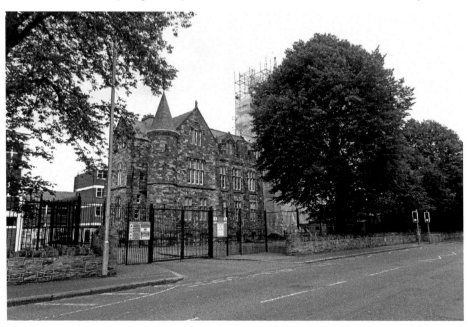

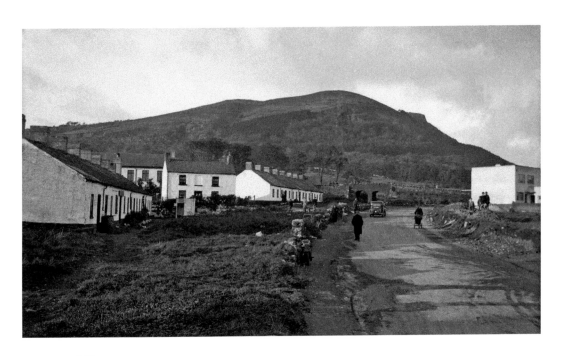

Cavehill

Cavehill, also known as Ben Madigan (Irish: Beann Mhadagáin, meaning 'Madagán's peak'), is thought to be the inspiration for the well-known book *Gulliver's Travels*. It was written by Jonathan Swift who was appointed Church of Ireland Vicar of Kilroot Parish near Carrickfergus in 1694. As he travelled to Belfast he looked at Cavehill and saw that the local landmark basaltic peak (now known as 'Napoleon's Nose') resembled a sleeping giant. The whitewashed cottages in this 1950s view housed workers in neighbouring limestone quarries which existed at Cavehill in late Victorian times. A horse-drawn railway (on the left-hand side of the road) transported the limestone to Belfast Docks and the route taken provides the name for the Limestone Road.

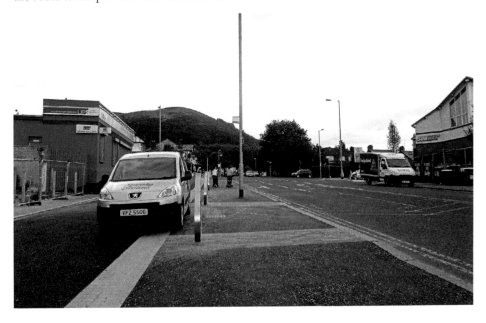

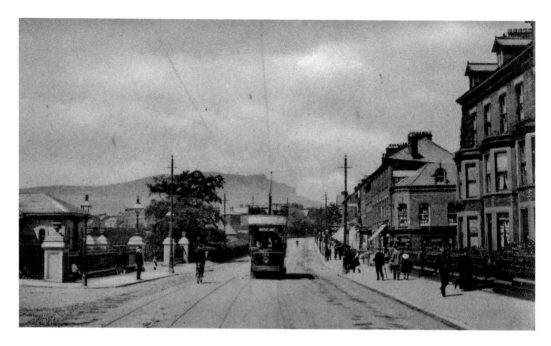

Waterworks

In the early 1800s the fast-growing town of Belfast was experiencing water shortages. The expanding population (20,000 in 1800 and 349,000 in 1901) and the industrial needs of linen mills and various factories all required greater supplies of water. The Belfast Water Act of 1840 brought a new organisation called the Belfast Water Commissioners into being and their function was the provision of fresh water, resulting in the construction of the Waterworks (above left). But various disputes over water rights and rights of way continued for many years and by 1865 the effects of a water famine resulted in the comment that there was not enough water in Belfast to 'boil an egg'. Further supplies of water became available and by the 1890s the Waterworks became a leisure facility – a role it still provides today.

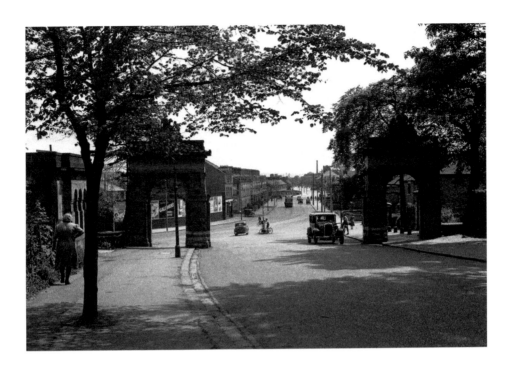

Fortwilliam Park

Local folklore records that the Earl of Essex probably had a fort in the Fortwilliam area during the reign of Queen Elizabeth I. By the 1870s there were several developments of new large, detached, middle-class houses with substantial gardens in select gated enclaves dotted around Belfast. A good example is Fortwilliam Park, which links the Shore Road and the Antrim Road. The location was once part of the vast estates owned by the Chichester (later Donegall) family. The gates at the Shore Road entrance (*above* in 1950) have now gone, but the Classical Roman triumphal arches remain, as does the original gate lodge and Gothic stone piers at Antrim Road.

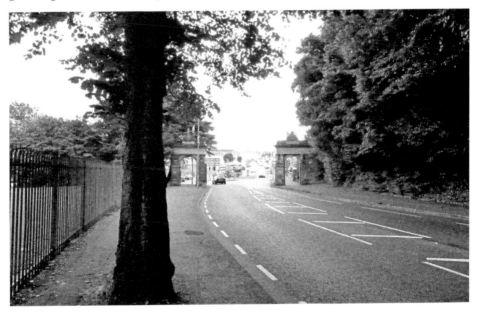

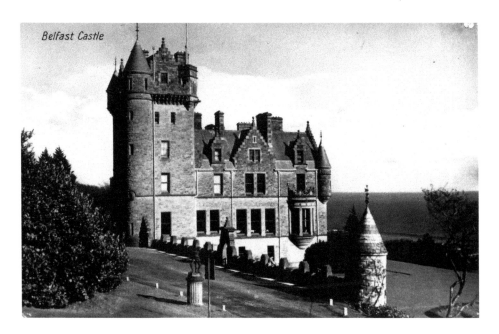

Belfast Castle

Belfast Castle

When the Normans invaded Ulster in the twelfth century they built a castle in the centre of Belfast near Castle Place. Sir Arthur Chichester (a number of thoroughfares still bear his name) built a new castle on the site in the 1600s. King William III stayed there on his way to the Boyne in 1690 but the castle was destroyed by fire in 1708. A new Belfast Castle (*above*) was completed in 1870 when Lady Harriet Chichester married the heir of the 7th Earl of Shaftesbury and the great wealth of these aristocratic patrons allowed for the construction of this grand Scottish Baronial-style residence. It contained thirty bedrooms and employed nineteen domestic servants. Set on a magnificent site on the slopes of Cavehill overlooking Belfast Lough, the 9th Earl of Shaftesbury donated the castle and estate to Belfast Corporation in 1934 and it is now a popular destination for functions, conferences and weddings.

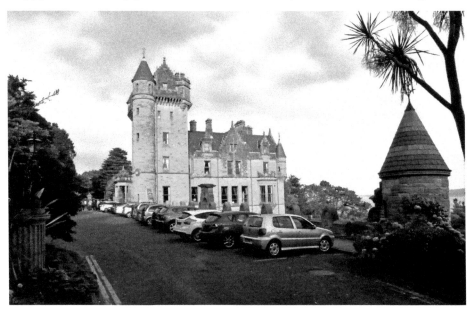

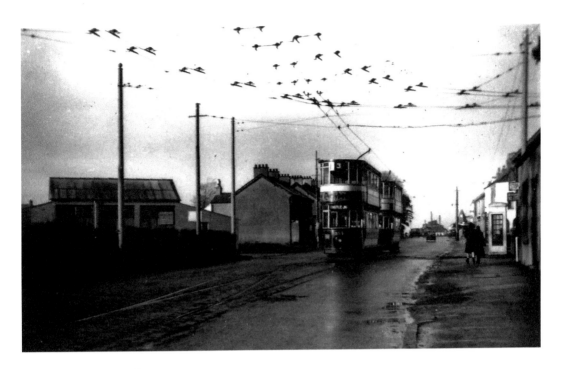

Glengormley Village

Strictly speaking Glengormley is not in Belfast but within the neighbouring Antrim and Newtownabbey Borough Council area. During the 1880s the residents of Glengormley (Irish: Gleann Ghormlaithe, meaning 'Gormlaith's Valley') were keen for the owners of the privately owned Belfast Street Tramways Co. to build a line connecting them with Belfast. As this was not forthcoming the locally sponsored Cavehill & Whitewell Tramway Co. was formed in 1882 utilising both horse and steam traction to the terminus in the heart of Glengormley village (above, on the last day of operation in 1949). The tram service is now a distant memory, but the old tram depot is commemorated by a modern shopping centre called 'Tramways', below left.

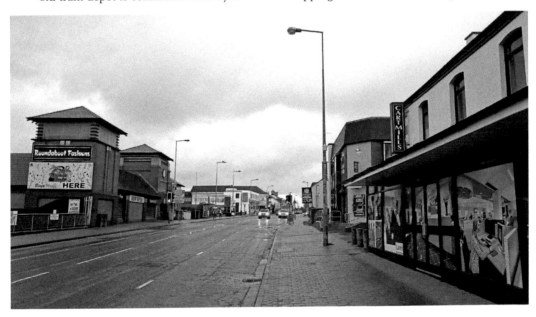

Bibliography

Allister, James H. and Peter D. Robinson, *Carson:. Man of Action*

Arts Council, *The Public Art Handbook for Northern Ireland* (2005)

Bardon, Johnathan, *Belfast: an Illustrated History*

Beckett J. C. et al, *Belfast, The Making of the City*

Brett, C. E. B., *Buildings of Belfast 1700–1914*

Carson, Edward, *A.T.Q. Stewart*

Coakham, Desmond, *Belfast & County Down Railway*

Doherty, James, *Standing Room Only, Memories of Belfast Cinemas*

Evans, David, *An Introduction to Modern Ulster Architecture* (1977)

Haines, Keith, *Images of East Belfast*

Hall, Henry, *Around Belfast*, (Francis Frith)

Lowry, Mary, *The Story of Belfast* (1913)

Masefield, Robin, 'Be Careful, Don't Rush', *Celebrating 150 years of train travel between Holywood and Bangor*

Maybin, Mike, *A Nostalgic look at Belfast Trams since 1945*

Maybin, Mike, *Ireland in the age of the trolleybus, Belfast 1938–1968*

McCarthy, Kieran & Daniel Breen, *Cork City Through Time*, McCarthy

McKay, Patrick, *A Dictionary of Ulster Place-names*

McMahon, Sean, *A Brief History of Belfast*

Pollock, Vivienne and Trevor Parkhill, *Belfast in Old Photographs*

Scott, Robert, *A Breath of Fresh Air, The Story of Belfast's Parks* (2000)

Templeton, George E. And Norman Weatherall, Images of South Belfast

Templeton, George E. And Norman Weatherall, *South Belfast History & Guide*

Walker, Brian and Hugh Dixon, *No Mean City, Belfast 1880-1914*

Walker, Brian and Hugh Dixon, *In Belfast Town 1864–1880*

Weir, Peggy, *Images of North Belfast*

White, Agnes Romilly, *Gape Row*

Websites

A Brief history of Belfast (Tim Lambert)

Belfast Hills Partnership

Early Belfast, The origins and growth of an Ulster town to 1750 (Raymond Gillespie, 2007)

Lord Belmont in Northern Ireland

About The Author

Aidan Campbell was born in Belfast in 1957. He spent his school days growing up in the family home on the Ballygomartin Road at Woodvale in West Belfast. After school, during his college years at the Northern Ireland Polytechnic, he lived at Merville Garden Village on the outer reaches of North Belfast. He lived at Myrtlefield Park in South Belfast during his early working career and was a 'blow-in' to East Belfast over twenty-five years ago. He currently lives in retirement at Knock with his wife Christine.

He took early retirement following a serious illness some years ago and now devotes his time to writing local history books to raise funds for a range of local charities. Since 2005 he has published eleven local histories on areas of East Belfast including Beaconsfield, Knock, Cherryvalley, Gilnahirk, Castlereagh, Cregagh, Stormont, Sydenham, Belmont and East Belfast Revisited Volumes 1 & 2. He recently crossed the border into South Belfast to author a history of Newtownbreda.

Aidan is a member of the East Belfast Historical Society, gives talks to a wide range of community groups, writes columns for the local press and contributes occasionally to local radio and television. There are more local history books in the pipeline.

www.eastbelfasthistory.com

Also Available from Amberley Publishing

This fascinating selection of photographs detailing the history of
the trolleybus in Belfast.

Paperback

9781848684669

Available from all good bookshops or to order direct
please call **01453-847-800**
www.amberley-books.com

THE AUTHORISED BIOGRAPHY OF
BOBBY
BUCKLE

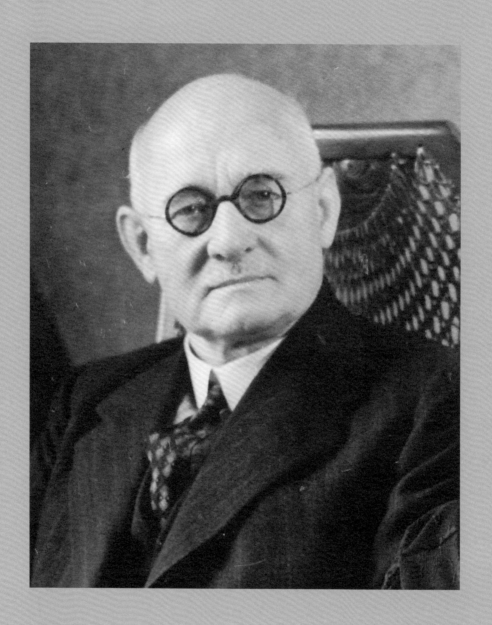

THE AUTHORISED BIOGRAPHY OF

BOBBY
BUCKLE

SPURS FOUNDER AND FIRST CAPTAIN

Christopher South

BOBBY BUCKLE MATTERS PARTNERSHIP

This book is dedicated to pretty football

First published in 2020 by
Bobby Buckle Matters Partnership

Text copyright © Christopher South 2020

British Library Cataloguing-in-Publication Data
A catalogue record for this book is available from
the British Library

ISBN: 978-1-83805-380-2

Designed by Andrew Shoolbred
Printed in Great Britain by IJ Graphics

Contents

Foreword

As Tottenham Hotspur's record appearance holder, I am delighted to write the foreword to this book. As a player, captain, and trophy winner who spent 17 years wearing the famous lilywhite shirt, it is an honour to pay tribute to arguably the club's most important founding father. Without one of my predecessors as Tottenham skipper, Bobby Buckle, it is no exaggeration to say there would have been no career at Spurs for me to enjoy and reflect on. There would have been no Tottenham Hotspur full stop. Every player, manager, fan, director, or indeed anyone with any connection in the club, owes Bobby an immense debt of gratitude.

It is remarkable to think that when I was doing my bit to steer the club to cup-winning success at Wembley in front of 100,000 people, or leading the side out in world-famous venues like the Nou Camp, Tottenham's success and global reputation had originated with a 13-year-old schoolboy and his friends forming the club a century before in a little corner of North London. Just imagine that: a group of kids barely into their teens came together to create a side that would become one of the most famous in all of world football.

Bobby was at the heart of that extraordinary story. Discovering how he and his friends formed the club and played those very first games on Tottenham Marshes is to hear a wonderful tale of youthful endeavour and ambition. I love it that the side took on teams with players older and more experienced than them. I think it's great that the Spurs then were seen in some circles as young upstarts. They pioneered the sport in the capital, quickly gathered

growing numbers of fans and were soon the pride not just of Tottenham but North London and beyond.

By the time Spurs won the FA Cup in 1901 – less than 20 years after being formed, and as the only non-league side ever to do so – they were arguably the biggest club in the south and ready to write a remarkable story that continues to this day. And Bobby was still present at the Lane, having hung up his boots to provide vital administration and leadership at board level to turn the club professional.

It's said of Bobby that he had a philosophy that the players and the fans came first: that it was their club, representing the area. Loyalty to that ethos was paramount. That chimes exactly with the principles I was brought up on from the very first day I walked through the gates at White Hart Lane as a teenage trainee. They were the same kind of beliefs instilled in me by Bill Nicholson and Eddie Baily, and shared by Keith Burkinshaw. Those values went way back, right to when Bobby and his mates competed in those early years: play the game the right way, be competitive but fair, and remember – it's the club and the fans who you play for.

Almost 140 years on it is marvellous to see the incredible new stadium, packed to the rafters with fans from around the world cheering Tottenham on - and just yards around the corner from that house on White Hart Lane where Bobby lived and did much of the groundwork to make it all possible. It is some story.

Steve Perryman MBE

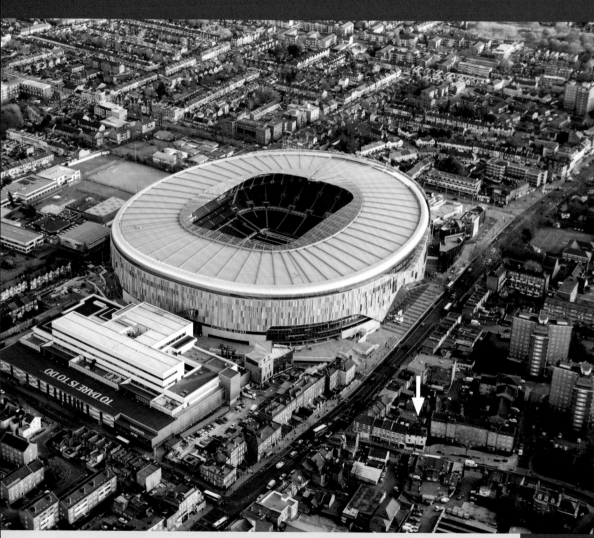

Close to home. White Cottage sits quietly in the shadow of the new stadium.

Preface

This is not a history of Tottenham Hotspur nor is it the work of historians. It was created by a small team united by ties of family, club and school, who were determined to give Bobby Buckle the long-awaited recognition he deserved. Phil Nyman first recruited two others, Barry Middleton and Arthur Evans, who went to the same school as Bobby, Tottenham Grammar. They in turn recruited Bobby's grandson, Michael Mackman, who then enlisted Kenneth Barker and the author, both of whom are grandsons of Bobby's lifelong friend, Samuel South.

This is the story of a schoolboy who led the creation of an enduring global brand, then stepped away and was forgotten. The schoolboy was Bobby Buckle. The brand is Tottenham Hotspur Football Club. Born a few hundred yards from the site of Spurs' present stadium, it was Bobby Buckle, the club's first captain, first secretary and first recorded goal scorer whose vision and drive led to that stadium standing where it now does. It was Bobby Buckle who gave Spurs its White Hart Lane address. It was this boy born in a suburban back street whose energy and spirit set a pattern for Spurs that straddles three centuries. And it was Bobby Buckle who disappeared from the scene of his triumph in a way that, until now, has puzzled his family and admirers.

To understand the scale of his achievement we must understand not only how it all began but where and in what tumultuous times.

Robert "Bobby" Buckle was born at 5 Stamford Street (now called Penshurst Road), just off White Hart Lane on 17th October 1868 when the British Empire was in its pomp and Victoria had 33 years still to reign. He was the third child of a coachman, William Ebenezer, who was then aged 35 and his wife, Emma, then 41. They had married in 1858.

When Bobby was two years old the family moved from their crowded little terrace home in the noisy shadow of the GER railway embankment to a new home owned by his father's employer. It was the shortest of home hops, just round the corner, under the railway bridge and into the next street; a matter of a few hundred yards. Yet when Emma took little Bobby in her arms and carried him from his birthplace she was carrying the man destined to put that

day's brief journey into history with three magical words that would fall from the lips of countless millions throughout the globe long after Emma, her boy, the entire household were dead and gone. Those three words were White Hart Lane. Add one more word, Tottenham, and we have the address that has made an otherwise obscure London suburb famous for football on every continent even if it is a tongue-twister for some.

By happy chance Bobby's new home, White Cottage at No. 7 White Hart Lane is still there. If visitors to the shrine stand in the right place they can see the mighty modern Spurs stadium across the High Road, towering over the neat little double-fronted villa with its five sash windows and tiny front garden divided by a path to a door given dignity by a half-moon window over the lintel. It is tempting to leap ahead and discover the part this house played in history but let the Buckles settle in and set the scene.

By the time Bobby was born, his father was in private service as coachman to Joshua Pedley, a rich City lawyer who lived in some splendour in Tottenham and was to prove pivotal in this story.

Becoming a coachman was a colossal leap in social status from clod-hopping, impoverished Suffolk farm labourers to the elite of the London working class. Only a few years earlier a removal order had forced his parents and siblings to leave the village of Packenham, where they were refused financial support, and throw themselves on the charity of their original home village of Woolpit.

What was it in the Buckle genes that within a generation produced the wily whiz kid Bobby Buckle? For years, perhaps centuries, the Buckles had eked out a living in Suffolk obscurity under the rule of the mighty Hervey family. From horizon to horizon all the Buckles ever saw was the vast Ickworth estate around the Hervey's massive mansion.

The only clue might lie in their piety. Their steadfast adherence to the Strict Baptist faith perhaps gave them strength but it may also have given them trouble.

By 1854 when Bobby's father sought his fortune in London, the family were living in the village of Horringer

White Cottage

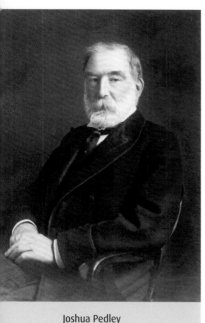

Joshua Pedley

where the Church of England Rector was Lord Arthur Charles Hervey, fourth son of the first Marquis of Bristol. It is tempting to suspect that to be a Strict Baptist in the parish where a son of the potentate in the Big House held holy sway would have been uncomfortable and limiting to any glimmer of ambition, especially as the Baptists harboured hopes for the disestablishment of the Church of England.

However, opinion is divided. One Baptist historian guesses the Buckles would have been second-class citizens but another social historian of the era holds that the Church of England found Baptists more tolerable than other Christian sects and denominations for several practical reasons. So all we may safely draw from the Buckles' piety is that it honed any genetic tendency to an independent and thoughtful disposition.

How did a poor Suffolk village boy land such a plum job as coachman to a rich lawyer in London? The clues are few. It is possible he was working in the Marquis's stables at Ickworth. That would have given him a useful grasp of how to handle carriage horses. It may be significant that his elder brother, John, was working as a house servant for a barrister, John Crosbie, who had retired to Horringer. Crosbie may have put in a word for him on some lawyers' grapevine that reached London. Anyway, William went, perhaps cadging a lift on a cart, and taking little with him but his hopes, his faith and the love of Emma Foster, a Suffolk serving maid some five years his senior. She may have gone ahead and he followed to find her. Certainly, she had a maid's job in Tooting by 1857. Somehow they were reunited. The romance flourished. They were married in Marylebone in 1858 and set up home in nearby Shouldham Street, William by then calling himself a coachman.

Three years later their first child, another Emma, is born and we find them in the Forest Gate area where Joshua Pedley, lawyer and landowner, lived the sort of lavish life that would have demanded at least one coachman and groom. Somehow someone brought together these two, the humble William and the wealthy Joshua. It could have been lawyer Crosbie back home in Suffolk, it could have been Henry Evans a groom with whom the Buckles shared

lodgings, it could have been neither. We may never know. We know only that this tenuous link was strong enough to change sporting history.

For by 1871 Pedley had set up a very grand establishment at Trafalgar House in Tottenham and installed his coachman William and family in a handy home nearby. Thus the Buckles reached Tottenham, an obscure family arriving in an unimportant suburb. Yet this is the almost magical moment when the twin destinies of the unborn Bobby Buckle and the undreamed of Tottenham Hotspur first began to converge. It would take years but the seed was sown.

William soon settled into the routine of driving his new master between his City office near Cannon Street and his quiet home in the Tottenham countryside.

That countryside shrank almost by the day under a tide of bricks and asphalt. Two new railway lines served a stampede to live beyond old, crowded London. Neat streets of little terraced homes with a bay window and a token front garden were filled with aspiring middle class clerks almost as quickly as they could be built. So, as well as the tide of bricks, young Bobby lived at a meeting place of two human tides – those quitting the capital for Tottenham's countryside and those, like the Buckles, quitting the countryside to seek their fortune in the capital.

Market gardening had been the area's chief industry. Now the market gardeners were in rapid retreat up the Lea Valley. Bobby Buckle's young world must have been full of roofers, carpenters, painters and bricklayers laying yellow bricks still warm from brickyards on the marshes where before long Bobby and his friends would make history. New streets sprang up before his eyes with names drawn from the Empire, heroes, victories and pleasant, pretty places in the English countryside.

Meanwhile, his father was a deacon and an increasingly important figure in the Claremont Street Strict Ebenezer Baptist Church. Bobby's Sunday School studies would have demanded discipline, the development of a good memory and early experience of public speaking. The Bible and other texts such as the eagerly-awaited monthly

"Gospel Standard" with the latest hymns, would have inculcated a respect for the power of the English language. Even Bobby's pleasant singing voice was cultivated in the bleak little chapel where unaccompanied voices obeyed a tuning fork to hit the right key. Much later his singing served him well at a grand football occasion. All of these things would have been useful when, very soon and still very young, he would enter public life.

At first they shared with three lodgers. Later, as the family grew and, since White Cottage probably had only four bedrooms, we can only guess that William and Emma had one, the girls one, the boys one and from 1891 this former housemaid had a maid of her own who would have taken the fourth.

Amid all the house building around White Cottage, another great movement was sweeping across Bobby's scene. The English had played more or less brutish versions of football for centuries. The Buckles' ancestors may well have played a wild cross country rampage called camping which could be close to open warfare. Indeed, camping fell out of popularity for a time in Suffolk in the late 18th century after two players died in an inter-village match. Now the rough sport was being tamed by rules. The Football Association had been founded in 1863. A wild enthusiasm for "soccer" was gripping the nation with the North and the Midlands in the van and the capital playing catch-up. The biggest and most controversial single change was still to come and in this Bobby was to play a vocal and decisive role.

Football equipment, too, was changing. The days of risking disease when inflating a pig's bladder by blowing through a broken clay pipe stem were ending with the invention of an India rubber version. By the 1880s rubber was used inside a neat ball that no longer needed two buttons to secure the leather panels. Meanwhile, goalposts still lacked a crossbar and were linked by a length of tape and it had not been until 1877 that the duration of a game was officially set at 90 minutes.

It is from this time that we get a first glimpse of what was to obsess Bobby's young life and make Tottenham a name known internationally. Family legend tells how his

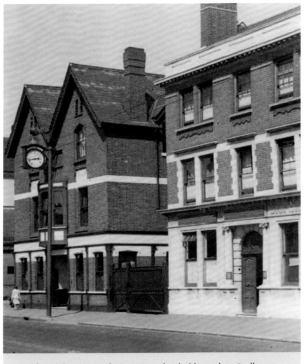
The Red House and Dispensary funded by Joshua Pedley

mother despaired because her boy would play his version of football on the street, kicking the toes out of his expensive high-laced boots. To own even the most primitive football was a dream. The real things made of 12 or even 18 leather panels stitched together by hand could cost more than a man earned in a week.

Bobby made do with the stones he kicked along the pavements and gutters of Tottenham High Road, dodging the carts and horse-drawn trams. All this played hell with his boot-leather. Bobby had caught the bug and it was serious. Mother moaned but he was hooked.

When in the 21st century we jostle through match-day crowds thronging the High Road and streaming into the immense stadium, it is not too fanciful to imagine we glimpse the ghost of young Bobby sending stones spinning past the very spot where we now enter. There he goes,

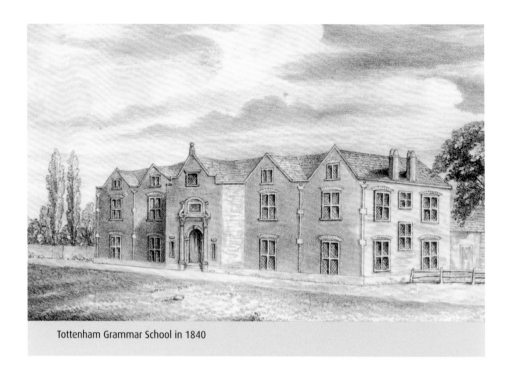

Tottenham Grammar School in 1840

that Buckle boy and his silly stones forever working out new dodges to outwit his unseen opponents with clever feints and fancy footwork. There he goes again, weaving his imaginary ball through pedestrians' ankles, risking being run over in the gutter.

It is obviously inconceivable even in our fantasy that this bothersome boy has any notion of the gigantic structure which will one day, partly thanks to him, tower over his pavement football field, but it is conceivable that in his obsessive rehearsal of tactics lay elements of the stylish play that one day quite soon would be the hallmark of Spurs for generations and attract huge crowds almost from the start. It was what all his life he would call "pretty" football. But that is a great leap ahead. All we can safely say at this key point in the story is that something life-changing was about to engulf the young Buckle's days and at first it had nothing to do with football.

We know from later evidence that Joshua Pedley, who was born into a wealthy family, protected and encouraged

the Buckles. When he died in1910 leaving the equivalent of £19 million, he had made sure "my old and much respected coachman" received what would now be worth about £10,000 a year until William died aged 91 in 1924.

So it seems probable that, as a school governor, Joshua Pedley put in a word for Bobby at Tottenham's prestigious Grammar School where the boy became a student in 1881 at the age of 12. The school had at that time just emerged from the lowest point in its 300-year history and was thriving. In the 1860s an inspector declared it was "doing as much harm as good to the education of the locality." A strong headmaster and vigilant governors had redeemed the situation and as the population grew so did demand.

When Bobby, wearing his red-trimmed, black serge school cap, entered the 1840s building at Tottenham High Cross, he must already have done well at an unidentified primary school because there is a tick in the grammar school register as a boy with the "highest standard presented at last school." He was one of 45 new boys, bringing the school roll to 90. Whether Pedley stumped up the fees or Bobby secured a scholarship we do not know but we can assume that here was his first taste of a world of organised sport and he made friends with a group of boys who shared his fixation with football.

Many of them came from backgrounds different from the Buckles. Tottenham then was a prosperous place. A glance at the faded streets around the present stadium shows the remnants of those days when merchants and professionals built imposing residences. A few of them were incorporated in Spurs' new stadium and the grandiose stone façade of a dispensary given to the community by Joshua Pedley is preserved in the Spurs shop.

Small, blue-eyed but short-sighted, Bobby cannot have struck his new friends as an obviously athletic figure. They were soon to think again.

Whatever they made of him, these lads shared Bobby's football fever and from their chatter about new kit and new rules there emerged an idea that was to change the face of London football.

Just Kids Under a Gas Lamp

It was 1882, the foundation year of eight great clubs that survive to this day, including Burnley, QPR and Torquay. It was the year the FA ruled that a player must use both hands in a throw-in. Our lads could have discussed this as they walked along Tottenham High Road. They could also have talked about the shameful state of cricket. For this was the year imperial England, to the nation's grief and astonishment, were defeated at the Oval by a team of mere colonials from Australia. This shock led to the famous Ashes tradition and must have added to the boys' dissatisfaction with a sport that could not be played in the winter.

With the boys' minds working along these lines we come to the single most dramatic moment in the splendid history of Tottenham Hotspur. The story is part of football folklore. The Gas Lamp Legend has been told so many times in so many ways that it is in danger of drifting into the world of myth rather than the real and reliable. Was the mighty Spurs really created by a few schoolboys standing under one of the 60 gas lamps that lit the length of Tottenham High Road? The image of children founding something so monumental that it survives to this day seems implausible. Yet there is good reason to believe that is exactly what happened. The words of Bobby himself echoing down the years within his family testify to the Gas Lamp Legend. Bobby's grandson, Michael Mackman, was often told by his mother that her father, Bobby, was one of the boys at that historic meeting.

As a devoutly religious and truthful man Bobby would not have "remembered with advantages" nor had he any motive to concoct what he might otherwise have dismissed as a cock and bull story. Those who knew him agree that in private conversation he was a man of few words and those

words were uttered slowly and deliberately. So, when he told his wife, Ethel, how Spurs started under that street light and she relayed his words to their children, we have history from his mouth faithfully relayed through his family for three generations.

"Let's start our own club!" was the unanimous cry from the boys.

In that moment the Mighty Spurs hovered in the air, an abstract notion. The great wheel that would roll on as it has to the present day had been set in motion while pavement passers-by went their ways unheeding witnesses to history.

Quite how many boys were there at the epochal moment is uncertain. Some say as few as four. Others a dozen. A scrummage of boys' names straddles the centuries – the Anderson brothers, Beaven, the Casey brothers, Dexter, Leaman, Wall, the Thompson brothers.... But it is certain that in every list of names ever assembled R. Buckle is always there.

He was 13.

Despite his youth, we may be confident he spoke solid sense rather than wild imaginings. As an old man Bobby told a newspaper this of how the club started:

> "I was one of the original founders of the Spurs. When I was a boy at Tottenham Grammar School a few boys, with myself as one of the leading figures, decided that we would form a football team – and that's how the Spurs were born."

Another clue to how it all began comes from P.J. Moss who appears as goalkeeper in the first team photograph. In an interview in the Sunday Pictorial in December 1929, almost half a century after the event, he singles out a key match that gave the boys the chutzpah to get more organised.

Casting his mind back to boyhood, Moss said: "In the spring of 1882 the Tottenham Grammar School and St John's Middle Class (Scottish Presbyterian) School played a match on Tottenham Marshes." As a result of that match, and probably after the legendary gas lamp meeting, a formal

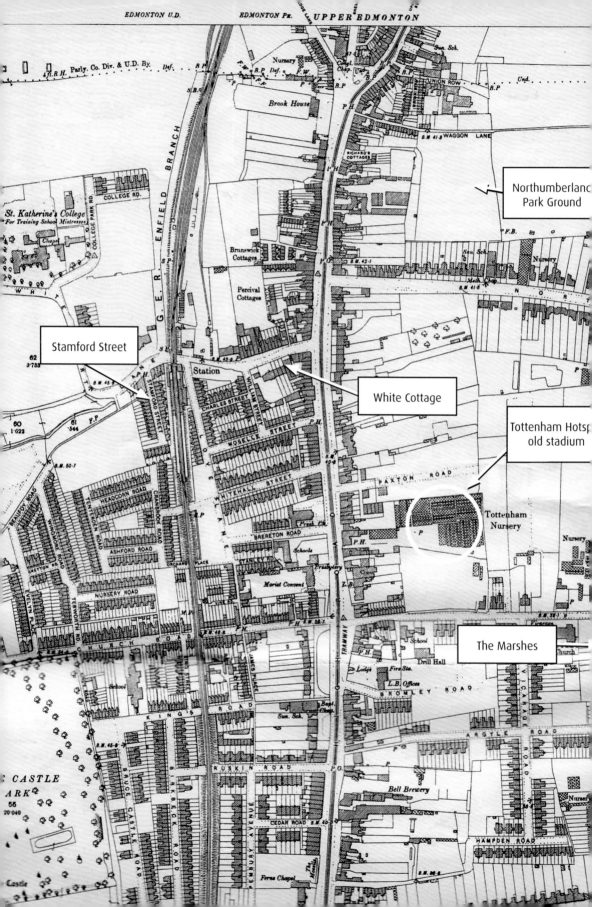

Stamford Street

White Cottage

Northumberland Park Ground

Tottenham Hotspur old stadium

The Marshes

meeting was held at the YMCA "and Tottenham Hotspur was formed."

The Moss account goes some way to confirm the traditional story but old men's memories can fail them. Even Bobby, famous for his power of recall, mistakenly stated in 1950 that he was 15 at the time of the gas lamp meeting whereas there can be no doubt he was 13. So the old goalie's memory undoubtedly let him down when he spoke of the spring of 1882. Everything points to it having been much later in the year. The very earliest club records have Bobby captaining Spurs on September 5. This would have followed the more formal meeting that regularised the wild enthusiasm under the gas lamp.

What best fits the scanty evidence is that in the last days of August, having spent the summer playing for Hotspur Cricket Club and about to return to school and a new football season, the boys formed a scratch team to play on the marshes. Against whom we may never know but as far as Spurs fans are concerned that rough game on rough ground was the hinge of history. Our boys, presumably triumphant and full of enthusiasm for the winter game, started to head back to their scattered homes. On reaching the High Road, they paused to talk. They had had a great afternoon. They had tasted triumph. They wanted more. Again, we may never know which of them lit the fuse but within days it had exploded into a proper little club complete with written records.

The boys had nothing. No name. No kit. No money. Not even a football. And nowhere of their own to play. What was to become a sporting and commercial colossus was still just an idea.

The name problem had an easy solution. As we know, most of the boys, Bobby probably included, played for Hotspur C.C. which took its name from Harry Hotspur, nickname of the historic hero of the Percy family who as the Dukes of Northumberland owned land in the area. Hotspur C.C. gave its backing to Hotspur F.C. and even gave it money for goalposts and corner flags. Other claimants to the Hotspur name may have caused a momentary doubt but they soon disappeared.

Opposite: A map of 1895 showing how close Spurs has remained to its community.

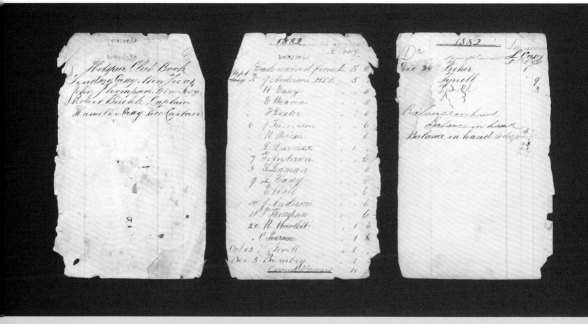

Hotspur F.C. Club Book from 1882. R Buckle listed as Captain.

A national trend towards creating public parks for recreation had been under way since the 1860s but there was no such formal home for the infant Spurs. In their search for space to play the boys did what other football-mad Tottenham youngsters did and headed for the rough public grassland of the Marshes beyond the railway line between Cheshunt and the capital. The result was occasionally comic and often chaotic. Our boys would diligently mark out an area well before a game and then, when they arrived back to play, found another team had pinched their pitch. Sometimes they had to fight for space against teams so ill-equipped that they lacked even a ball and used a bundle of rags. At least our boys had a ball, given by a brother of one member. But balls remained an expensive problem. We know that five years later they paid seven shillings and sixpence for a second-hand replacement.

Their very first matches are lost in marsh mists but the first reported game was an easy 9–0 victory over Brownlow

Rovers in which, according to the Tottenham Weekly Herald, "Buckle did good service for Hotspur."

Often captained by Bobby, Hotspur F.C. seemed more business-like than the others. They held meetings, sometimes by candlelight in half-built houses on building sites. Bobby took the chair. They kept minutes. They made rules. They made duty rotas, setting out whose turn it was to carry the blue and white painted goalposts one father had fashioned to the pitch from Northumberland Park station. Mr Martin, the station master, had offered storage space that later, in 1885, was to include the new-fangled crossbar Bobby's fellow winger, Billy Harston, had made for one pound five shillings.

So, if those teeming thousands of fans who crowd the platforms on match days sometimes grumble about the train service they could spare a thankful thought for Mr Martin who did the club a favour long ago when it had neither friends nor fame. At least the grateful boys

voted in 1885 to give Mr Martin "a present." That tip may have been mere pence but the boys showed the sort of courtesy lacking in rival, rougher local clubs. Other boys' teams in the same neighbourhood came and went, fought fist fights in back streets, rose and vanished. Why did our boys' endure?

By a chance that borders on the miraculous, a few pages of a meticulously kept day book from Spurs' first year have survived. They are stained, dog-eared and crumpled but, considering their age and the life they have led, these flimsy fragments of Spurs history are astonishing. The neatly penned record of the boys' sixpenny subs tell us little we did not know or might have guessed yet they tell us a great deal. The pages' contents are humdrum but their message is plain: these boys were not mucking about.

If anyone asks how it is that Spurs grew to their present global scope, show them these scraps. By all means boast about cups won and footballers' deeds, but show them these scraps. They are powerful evidence of a very organised bunch of boys. These flimsy pages are the solid foundations on which Spurs built from the earliest days. Who wrote them? It can only have been Spurs' speedy outside left, sometime captain and joint centre forward Bobby Buckle doing his duty as secretary scribbling away, burning the midnight lamp oil at No.7 White Hart Lane. He may have had his Grammar School homework to do, too.

What sort of a character was the Buckle boy in these formative years? Clues are few but perhaps the most powerful hint comes from his image in the first-ever Spurs team photograph (see facing page).

The boys won the support of a useful adult, John Ripsher, an influential member of All Hallows Church and of the YMCA where they ran into trouble for playing football in the basement. Ripsher was a forgiving man and let them meet at the YMCA on condition they attended scripture classes at All Hallows parish church on Wednesdays. We can only speculate how this link with Anglicans went down with Bobby's strict and exclusive Baptist father. Even worse, one day after church they were caught playing cards and had

The Cool Birthday Boy

Useful clues to Bobby's character in these formative years are found in this precious picture. It is the earliest known image of Spurs. Bobby is second left in the front row. It is October 17th, 1885. It is his 17th birthday. Perched on a hump of turf, Bobby asserts himself by inching his shoulders just ahead of his neighbours. Conscious of appearances, he has removed the spectacles he wore on and off the pitch. His centrally-parted hair looks neater than most of his mates'. This was probably the first time he had faced a photographer. The Buckles did not waste money on such frivolous vanities. Yet Bobby's face breathes self-confidence. His steady gaze implies familiarity with being in the thick of things. While some slump and his lifelong friend Ham Casey at top right contrives a special sportsman's pose, Bobby sits bolt upright, his arms resting naturally as he stares back at the lens with intelligent composure. From this basket of puppies, which would a wise selector pick?

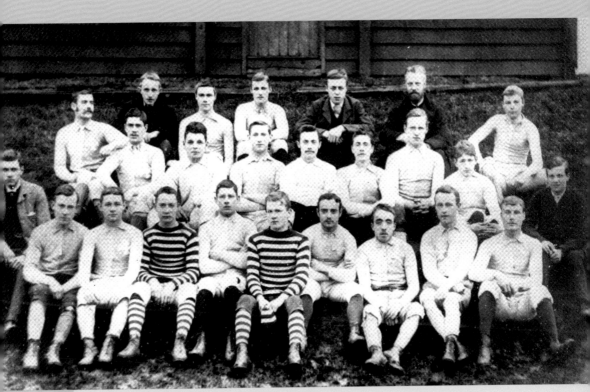

The first ever team photo, Bobby 2nd left in front row. Ham Casey is far right on the top row next to John Ripsher. The photo was taken on Bobby's 17th birthday.

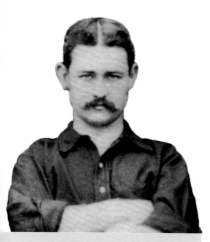

Bobby, about 1894, from a team photo

to find a new home at the alcohol-free Red House Coffee Palace set up by lawyer Pedley.

Despite Bobby's assiduous organisation, Hotspur F.C. had scant success on the field. We know from Spurs' own official history issued to mark Bobby's 150th anniversary, that he became the first known goal scorer for the club when they lost 3–1 to Grange Park in 1883. But we get only brief and conflicting glimpses of early games. An indication of their standard is that one match had to be abandoned after the ball burst and another when a player's leg was broken. We glimpse a game played on 6 January 1883 against a team who were to be bitter rivals, Latymer. Our boys lost 8–1. In December of the same year Latymer turned up with only five players but started anyway. A few more joined the game as it progressed. After 90 chaotic minutes the two teams could not even agree on the score and after a third match both teams submitted such contradictory reports to the sports editor of the Tottenham Weekly Herald that he refused to publish either. The next season Latymer fielded 12 men until Spurs spotted the trick at half time.

The rough and tumble of late 19th century amateur football also taught Bobby how to handle ridicule. He was unkindly mocked by surly Millwall fans because he played wearing his spectacles but he shrugged off their rude words leaving us to wonder how he ever managed to head a ball and score a goal without smashing his specs.

Do we again see the hand of captain Bobby in a crazy scene in which, despite all this nonsense, our boys made themselves locally famous not for throwing mud, fighting and cheating but for playing what Bobby often called "pretty" football? So pretty that they began to draw crowds. Dare we see in this the first signs of a future known for style as much as for scoring?

Goalkeeper Moss, who remembered an early inter-schools match, wrote in 1900 that "it is no exaggeration to say that 4,000 spectators surrounded the field." Clearly they came to see a club who, win or lose, were, as ever, a joy to watch. These spectators could be an unruly lot who threw rotten turnips at players and each other. But what irked

Bobby and his mates is that these spectators were watching them for free. As their success grew so did the crowds and they won increasingly prestigious fixtures and victories. Something had to be done about that.

Time passed without resolution while Bobby persevered with both football and his varying roles as secretary, treasurer, twin centre forward and as a famously fast outside left. By the time the pitch problem was solved Spurs were drawing ever bigger crowds, Bobby was a man of 20 conducting Spurs correspondence from the now famous White Cottage in White Hart Lane. He had had letterheads printed for the Tottenham Hotspur Football Club with his White Hart Lane address as early as 1888. Examples survive. The famous chant "We are Tottenham, Tottenham from the Lane" has its roots in this period long before the club moved into its present High Road address.

This was a period of extreme activity for Bobby. He seems to have become a man to whom people turned to get things done. Club growth brought a heavier burden of administration.

There were teams and fixtures to be organised and this must have been less easy when the only means of communication were face-to-face, the post, telegrams and messages put through letterboxes. Then there were the sports days and social events. And on top of all this he took on the secretaryship of the Southern Alliance.

Scan the local newspapers for these years and Mr R. Buckle pops up in a variety of roles. He was becoming one of those community figures who knows everyone and is known by everyone. The busy Mr Buckle. The reliable Mr Buckle. But always with time for a courteous chat. "His smiling face was a sight to behold," writes the local paper's football columnist after a match in 1896. "It was a clinking game," said Bobby after drawing with Millwall in front of 4,000 spectators. That gate "proves the public are prepared to pay for class football at Tottenham" said the reporter, describing Bobby as "the proudest man on the field."

Various Spurs histories give details of the club's football record in this period and that was the greatest part of Bobby's work but the committee also organised

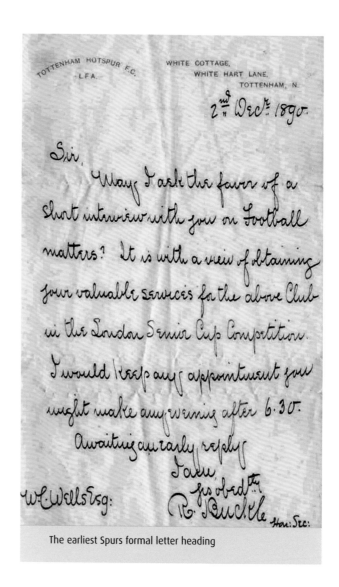

TOTTENHAM HOTSPUR F.C.
L.F.A.

WHITE COTTAGE,
WHITE HART LANE,
TOTTENHAM, N.

2ⁿᵈ Decʳ 1890.

Sir,

May I ask the favor of a short interview with you on Football matters? It is with a view of obtaining your valuable services for the above Club in the London Senior Cup Competition. I would keep any appointment you might make any evening after 6.30.

Awaiting an early reply

I am,

yrs obedtⁿ

R. Buckle Hon: Sec:

W.C.Wells Esq:

The earliest Spurs formal letter heading

social events to raise funds. There was a "Cinderella Dance" (everyone home by twelve), smoking concerts where men could be men together singing old songs and reciting solemn verses or light-hearted monologues. Bobby always helped run the athletics but not the rest although he gave the singing and dancing his support and attended at least one smoker to receive a testimonial for his "valuable services." He may have had an eye on how his pure-minded

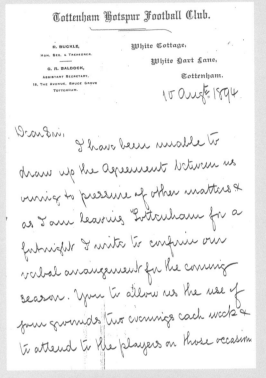

Tottenham Hotspur Football Club.

R. BUCKLE,
Hon. Sec. & Treasurer.

G. R. BALDOCK,
Assistant Secretary,
18, The Avenue, Bruce Grove
Tottenham.

White Cottage,

White Hart Lane,

Tottenham.

15 Aug.t 1894.

Dear Sir,

I have been unable to draw up the Agreement between us owing to pressure of other matters & as I am leaving Tottenham for a fortnight I write to confirm our verbal arrangement for the coming season. You to allow us the use of your grounds two evenings each week & to attend to the players on those occasions

also to attend on the team each Saturday both at home and away for the sum of 10/- weekly we allowing you in addition thereto your 1s travelling expenses in away Matches. On my return I will prepare a short agreement embodying the above terms – The players likely to use the grounds now are, J. B Gull – J.W. Welham, S. Briggs, A. Briggs, J. Shephard an. Cubberley.

Yours truly
B Buckle
Hn Sec.

Mr A Norris

Letter appointing A. Norris as Trainer

parents would regard a Cinderella Dance. Bobby may have been walking a knife edge to keep domestic peace.

We get a glimpse of Bobby's life at this period from the recently discovered club minute book recording ordinary meetings and annual meetings over the years 1885 to 1896. Entries show Bobby's forceful, imaginative approach to club football but that does not mean he always got his own way. In 1885 he failed to convince his fellows to scrap the 2nd XI and in 1889 he met what was to prove a fateful failure to hand captains the power "as usual" to select their teams. This attempt to ensure player power was lost 7–12 and is the first hint of his almost religious conviction that footballers should run football, that the men on the pitch

are the men who matter, their own masters. To him an almost mystical brotherhood had been formed out there on the misty, muddy marshes and he would not let it slip away.

This became a stubborn mind-set which, so far as we can tell, stayed with him all his life but which in the early years of the next century was to bring him misery and even mockery.

Because it was expected that every member should be able to play, the boys decided in the very earliest days to limit membership to 18. In essence this was still the spirit of Bobby's thinking. He was almost equally determined to protect the "purity" of Spurs. He did not want outsiders buying their way into power and out-voting his founder brethren. A member had to have been a veteran of the marshes in 1882 to be accepted. Bobby's hand can be seen behind the 1895 AGM resolution designed "to prevent a majority of new members from obtaining control of [the club's] affairs" by doubling the annual subscription for the growing number of newcomers. But while he was happy to wring more money out of newcomers he had been protective of old chums who hit hard times. When his fellow winger came up for re-election to the club in 1886, Billy Harston was well in arrears with his subs and should have been disqualified but Bobby spoke up for his friend, a fine footballer, and got the committee to give the boy a few weeks' grace to pay "all or part." Three years later poor Harston not only owed two shillings and sixpence from the previous season but had paid nothing in the present season. Members merely noted the arrears and apparently took no action. Spurs then really was a club of mates, kindly and pragmatic. It clearly reflected Bobby's "footballers first" philosophy. He may have been a demon for efficient paperwork but that should never get in the way of the game. It was a philosophy that would cost him dear.

From time to time the question of club colours turns up in these minutes. An entire learned book has been devoted to the history of Spurs strips but it is worth noting that as early as May 1886 Bobby proposed the colours we have today – blue and white. It would be a brave

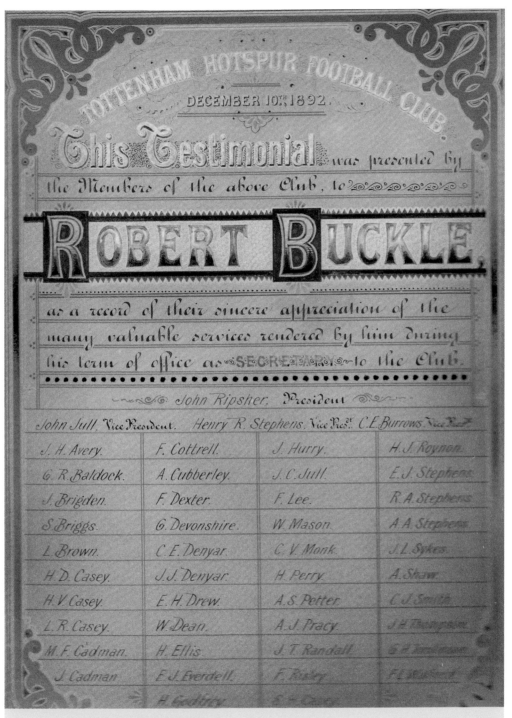

The first ever Testimonial given by Spurs

Facsimile from Sporting Life, 20th December 1895, advertising for opponents

proponent to insist Bobby originated Spurs' livery but, if he did, it would be only one of his many firsts for the club.

Thanks to a proposal from Bobby seconded by his mate Ham Casey, a refinement of club colours had been accepted in the previous year when Spurs wore a special kit for the Cup matches – a white Victoria Cross on the blue side of the bi-colour shirt. This emblem can be distinguished on the only club photograph surviving from those early days (see page 25).

The extent to which Secretary/Treasurer Buckle took decisions without consulting and told the committee later is hard to judge. For example, he reports that he had taken out a policy with Crown Accident Assurance to cover Spurs first XI and we are left wondering if he was both client and agent in this case since he was already involved in the insurance agency at his workplace.

Again, in 1885 he let the committee see a letter he had sent congratulating the newly-elected local MP. It is not clear he was asked to do this but it certainly showed a lively grasp of public relations; no harm in buttering up the local bigwigs. Was Bobby the club's first (self-appointed) Public Relations Officer doing a job that now involves a strong staff of professionals? Yet another Buckle first? Certainly it

POST CARD

THE ADDRESS ONLY TO BE WRITTEN ON THIS SIDE.

Mr. H Ball
159 Birkbeck Rd
Tottenham

✦ TOTTENHAM ✦ HOTSPUR ✦ F.C. ✦

R. BUCKLE,
WHITE COTTAGE,
WHITE HART LANE. TOTTENHAM

H. D. CASEY,
SHERWOOD LODGE,
PARK, TOTTENHAM.

Date as Post Mark.

v. Coldstream Guard
(replayed Cup Tie)

Dear Sir,
You have been chosen to play in the above Match on Saturday
next, at *Park*

Should you be unable to play, please advise us at once.

Yours faithfully,

R. BUCKLE,
H. D. CASEY, | Joint Hon. Secs.

DRESSING ROOM

3o'c 2 H Sharp

How players were notified of their selection for matches.
This Vs Coldstream Guards (Spurs won 7-0)

We're Going Places

A curious clue to the young Bobby Buckle's character can be found in a surprisingly decorative page of the club minute book. It was written after he had been elected both secretary and treasurer on 15 May, 1890. Bobby had had a hand in both these jobs earlier but now, as day-to-day boss of management and money, he had responsibility and power even if it was over a set of men and boys hardly anyone took as seriously as they took themselves.

How are we to interpret this sudden flowering of grandiose calligraphy more suited to deeds or a last will and testament? What was in Bobby's mind when he went home after the committee meeting that evening, dipped his steel nib in the inkwell and in his lamp-lit room wrote those opening words in such style? A young man larking about? Showing off his newly-acquired law hand to mates who still used the schoolboy writing learned at Tottenham Grammar? Is it a joke or is it the ambitious and newly-empowered secretary/treasurer putting down a marker?

If it is a marker, a symbol of serious intent using the solemnity of the law, then we could translate its message into modern English as: "I'm Robert Buckle. I'm the admin man of this outfit and we're going places."

A Committee Meeting was held at the Northumberland Arms. Park. Tottenham on Thursday the 10th July 1890

J Ripsher in the Chair

Present

Mess.rs J. H Avery, J. W. Bumberry, H. D. Casey, J. G. Hatton. J. Leaman. E. J. Stephens, J. H. Thompson Junr. and Hon: Secretary

Private Ground

It was Resolved That a Sub Committee consisting of Mess.rs Hatton. Jull. and Casey be formed for the purpose of again securing the Ground used by the Club during the past season on the same terms as before

Dressing Room

It was Resolved That Mr G Seager (the present Landlord of the N Arms) should be waited on with a view reducing the amount (Three Guineas) heretofore paid for the use of the Dressing Room. Mr Hatton and the Secretary accordingly attended that Gentleman who expressed his willingness to accept whatever sum the Committee thought fit to offer and it was ultimately

Proposed by Mr J. H Avery and **Seconded by Mr F. G. Hatton.**

That the Sum of £2.2. be given the Secretary to prepare the necessary Agreement

Cup Competitions

It was Resolved That the Club enter for the following

Bobby's first set of Committee minutes

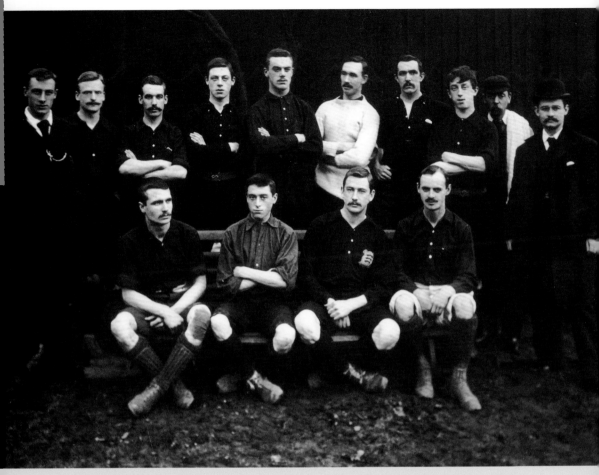

Bobby (far right) as a Committee member in 1894. The Trainer, A. Norris is in the white coat next to Bobby.

is the only flicker of political interest we detect until, many years later when he has left Tottenham, we will find Bobby careful to keep his voting power there.

For the 1888/89 season Bobby, with the help of Ham Casey and Jack Jull (probably their best man but available only in school holidays), found Spurs' first real home. They settled on a private area off Northumberland Park used for tennis in the summer. They shared it in the 1888/89 football season with Foxes F.C..

A Little Cockney Sparrow

Meanwhile, Bobby's private life was developing as successfully as his football life. He had left the grammar school aged 14 in 1883 and started work. Lawyer Pedley for whom Bobby's father had long worked had clearly kept a kindly eye on his coachman's son and changed the teenager's life for ever by giving him an opportunity at his office in the City of London. Bobby made the most of this chance and was still working there 66 years later having prospered in many ways. He even ran his own little property empire and insurance business as we shall explore later.

So much for Bobby's football and working lives thus far. His private life at this time remains his own business although a presentable, solvent, respectable, healthy and ambitious young man must have been on the marriage market. All we have as to his marital future is one tiny clue and even that is speculation. But at some point a little Cockney sparrow walked into his life.

The eight-year difference in their ages means he would scarcely have noticed her even if they were in the same room but she might well have noticed a talkative member of a noisy gang. This is Ethel Brown who was to blossom into a pioneer of that stalwart army of WAGS, the Wives and Girlfriends, who now steer great footballers through their crises and triumphs and it is probable that she and Bobby first saw one another under disreputable circumstances. Nice young ladies did not normally venture into public houses. Drink was seen by a militant temperance movement as the ruin of men and their families. Pubs were the gates of hell. But little Ethel was the landlord's step-daughter, peeping round a door or

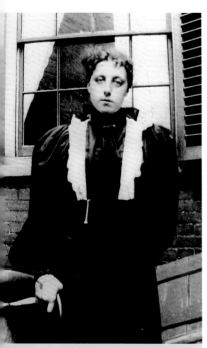

Ethel Brown, aged about 17, outside her step-father's pub

perhaps doing her bit for the family business by collecting empty glasses.

She had had a sad start in life. Born in Lambeth in 1877, poverty reached Ethel when she was only two. Her father William, a bookshop clerk, died less than three years after marrying. His widow, Mary-Ann, was doubly bereaved. In a short space she lost both the men she could call on for support because her father, a coachman like Bobby's father, also died.

We cannot rely on the misty-eyed notion of cockney cheeriness sustaining Mary-Ann in the way suggested by that all-singing, all-dancing 1930's musical "Me and My Gal." The only Lambeth Walk the young widow did was away from the South London borough. After struggling alone she eventually crossed the river to a strange land called Edmonton. Perhaps they were friends or relations but somehow Mary-Ann found shelter in the home of a warehouse porter and his family. It may have been a desperate step for her but it was momentous for two young people and even for Spurs because Edmonton was just down the road from Bobby's home in White Hart Lane. It was good for the Spurs story, too, for she could claim to be the club's first archivist. More of that later.

Mary-Ann, having tasted the delights of digs in Edmonton for a while, headed straight back across the river to marry a publican, Alan Ainsley, in the same Southwark church where she had married her first husband. She was now 32 and her new husband was 30. Little Ethel was plunged into a way of life that was to be hers until she married Bobby.

It was a rowdy life that reeked of beer and baccy. It could not have been less like the life led by the devout, sabatarian, teetotal Buckles. They did not drink nor sing rough songs. They sang hymns and drank weak tea. Did the pious Buckles know their boy Bobby frequented pubs? He could hardly avoid it because that is where the early Spurs held their meetings. It was at The Eagle in Chestnut Road, Tottenham in 1895 that they voted to go pro and at The Golden Lion in Edmonton Green that in 1898 Bobby and his mates voted Spurs into a limited company. One name,

Ainsley, links these pubs with Mary-Ann, Ethel and Bobby.

Mary-Ann was now Mrs Ainsley and part of a clan that ran Tottenham pubs for many years, including The Eagle and the Golden Lion. The Golden Lion was busy not just with customers but with family and staff. Ethel soon had two step-sisters and two step-brothers and the house at one time also accommodated a live-in barman and three barmaids. Most nights, if their pockets permitted, the numerous local football clubs would have met in the pubs that outnumbered local places of worship. Small wonder that, as she told her son Leonard very many years later, Ethel's stepfather had warned her as a child not to get involved with footballers as they were unpleasant young men known for back street fisticuffs.

Little Ethel, however, was developing the sturdy individuality she showed in later life. Even if barred from the bar, she probably did happen to notice a small, blue-eyed, lively, loquacious young man laying down the law at Spurs meetings in that slow, emphatic style he had made his own.

Meanwhile, Alan Ainsley had made sure the Hotspur boys met in his pubs by the simple expedient of giving them some money to make him a vice-president. It seems he could tolerate unpleasant young men if they bought his beer and the boys could scarcely snub their benefactor by meeting elsewhere.

But the Buckle family's greatest benefactor, the abstemious Joshua Pedley, was effectively and perhaps tactlessly snubbed. In an attempt to coax men out of pubs he created the Red House Coffee Palace, a monumental but booze-free public meeting place on the High Road. Now demolished, the Red House was at one time a venue for our boys to talk teams and tactics and much later it was taken over by Spurs as club HQ. Probably to the regret of the kindly lawyer his coffee never quite lured Tottenham's sporting youth from where "spiritous liquor" was sold.

So everything points to Bobby and Ethel's eyes first meeting across a crowded bar room at The Golden Lion. That much is speculation but it would explain what certainly happened next. One morning Bobby boarded his train to

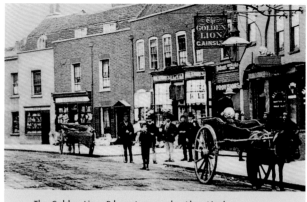
The Golden Lion, Edmonton, run by Alan Ainsley

work and found himself in the same carriage as a schoolgirl he recognised. It was little Ethel, the step-daughter of the landlord of the Golden Lion in the High Road and the Eagle in Chestnut Road.

Each day Bobby took the train from White Hart Lane station just a few hundred yards from White Cottage. Family tradition recounts that Bobby would stand at an upstairs window and peer sideways, out over the rooftops to spot the first puffs of steam and smoke as his approaching train left Silver Street just down the line. Then he would sprint along White Hart Lane in time to get aboard. Again we rely on Buckle family tradition to reveal what began to happen on the train.

Bobby would meet Ethel on her daily journey to school on the same train having joined it earlier at Edmonton Green. She usually had her school books with her and sometimes tried to catch up with neglected homework. Bobby, so the story goes, gallantly offered to help her with her studies. The years passed and for him at least, it developed into a locomotive love affair that endured until his death. But he had to wait a decade to make Ethel his wife.

When did Bobby tell his abstemious Baptist family that he had fallen for the step-daughter of a pub landlord? That is a little drama of which we know nothing except that

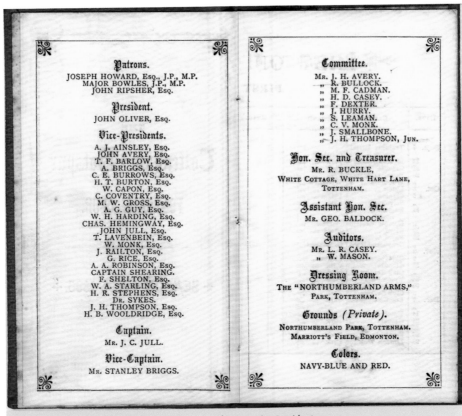

Patrons.

JOSEPH HOWARD, Esq., J.P., M.P.
MAJOR BOWLES, J.P., M.P.
JOHN RIPSHER, Esq.

President.

JOHN OLIVER, Esq.

Vice-Presidents.

A. J. AINSLEY, Esq.
JOHN AVERY, Esq.
T. F. BARLOW, Esq.
A. BRIGGS, Esq.
C. E. BURROWS, Esq.
H. T. BURTON, Esq.
W. CAPON, Esq.
C. COVENTRY, Esq.
M. W. GROSS, Esq.
A. G. GUY, Esq.
W. H. HARDING, Esq.
CHAS. HEMINGWAY, Esq.
JOHN JULL, Esq.
T. LAVENBEIN, Esq.
W. MONK, Esq.
J. RAILTON, Esq.
G. RICE, Esq.
A. A. ROBINSON, Esq.
CAPTAIN SHEARING.
F. SHELTON, Esq.
W. A. STARLING, Esq.
H. R. STEPHENS, Esq.
Dr. SYKES.
J. H. THOMPSON, Esq.
H. B. WOOLDRIDGE, Esq.

Captain.

Mr. J. C. JULL.

Vice-Captain.

Mr. STANLEY BRIGGS.

Committee.

Mr. J. H. AVERY.
 „ R. BULLOCK.
 „ M. F. CADMAN.
 „ H. D. CASEY.
 „ F. DEXTER.
 „ J. HURRY.
 „ S. LEAMAN.
 „ C. V. MONK.
 „ J. SMALLBONE.
 „ J. H. THOMPSON, Jun.

Hon. Sec. and Treasurer.

Mr. R. BUCKLE,
WHITE COTTAGE, WHITE HART LANE,
TOTTENHAM.

Assistant Hon. Sec.

Mr. GEO. BALDOCK.

Auditors.

Mr. L. R. CASEY.
 „ W. MASON.

Dressing Room.

The "NORTHUMBERLAND ARMS,"
PARK, TOTTENHAM.

Grounds (Private).

NORTHUMBERLAND PARK, TOTTENHAM.
MARRIOTT'S FIELD, EDMONTON.

Colors.

NAVY-BLUE AND RED.

Membership card, 1895–96 showing A.J. Ainsley as a Vice President

in later years Ethel embraced Bobby's religion without ever losing her taste for a bottle of stout.

We also know their snatched conversation on the train was not confined to Ethel's studies. It is certain this football fanatic rattled on about Hotspur F.C. And we can be equally sure he did not bore her. He had her hooked on Spurs. Ethel was so smitten she started a Hotspur scrapbook of cuttings from local newspapers which is still in their family and which she faithfully maintained through the years of their courtship. We will come to the mystery of why the scrapbook ceased and the deeper mystery of Bobby's break with Spurs, but first we re-join Ethel and Bobby's morning ritual. She would leave the train first. Bobby went

COCK-A-DOODLE-DO-O-O- !

[After the ball on Monday. The Saint came up to try and rob the Cock's nest and got scratched.

But he says he'll wring it's neck when he gets it down at Southampton !

on to Liverpool Street and then navigated his way through teeming pavements, hansom cabs and horse-drawn buses of a capital that ran an Empire and ruled the world to the offices of Pedley, May & Fletcher where he was working his way into his new world.

When Bobby first stepped into that office he must have been in awe. Until then, this working class lad lived his days against a background of home, schoolroom, chapel, cricket pitch and football field. Now his sharp blue eyes behind those thick lenses were given a first glimpse of the way the wider world's wheels work. Even when he later dignified himself with a moustache he still held a low rank in the office hierarchy and we know that at first

THE FIRST ROUND FOR THE CUP.

THE THIRD ROUND.

The Referee calls "Time" for the third round between those game fighters Luton and Hotspur.—[Let us hope it will be the last round.—ED.]

Cartoons from Ethel's scrapbook

his schoolboy script was mocked. But that quick grasp of a situation which still served him dashing up the wing on the noisy pitch could now come into play in the hushed, gas-lit atmosphere of an office reigned over by his benefactor amid deed boxes and the ceaseless production of beautifully penned contracts and codicils, conveyances and clauses. His was a humble role but the place fitted him like a glove. Even as an old man he was blessed with a powerful memory and this must have helped him learn formally and informally

This is a period that had a profound impact not only on his entire working life but also on his administrative work for Tottenham Hotspur. We can only guess how legal knowledge rubbing off on this lowly office boy would affect every football fan attending a Spurs home game to this day.

An outside spectator of this single-minded little man might think that, apart from his devotion to Ethel, Bobby was a rather dry, driven pen-pusher whose football had lost its friendly fun. Yet we have clear evidence otherwise in the London Middlesex Gazette on 28th August 1897. This gives a very different picture as well as an early clue to what was to be the Buckle family's enduring devotion to seaside holidays:

> Anyone requiring a season ticket for the Tottenham Hotspur ground should at once apply with postal order for 15s to J.H. Thompson, junr., 57 Northumberland Park, Tottenham. All applications for membership must be made to the genial and popular general Hon.sec., Mr Robert Buckle, White Cottage, White Hart Lane, Tottenham. The latter, by the way, is just now sojourning by the "sad sea waves," as a health recruiter for the forthcoming heavy season, Eastbourne being the venue, I believe.

"Genial" is a word repeatedly used to describe Bobby. A football gossip column in 1896 refers to the "genial" Buckle playing for the Old Crocks on their last day at Northumberland Park.

But Bobby needed all his genial disposition and popularity to tackle the rather silly Scandal of Payne's Boots which eventually tipped Spurs towards becoming professionals. The essence of amateur status under FA rules was that players received no reward in any form. Ernie Payne was a fine player who agreed to turn out for Hotspur F.C. on 21st October 1893 although he was on the books of Fulham F.C. When he arrived in Tottenham on match day he was desperate. Someone had stolen (or maliciously hidden) not only his shirt and shorts but his precious boots.

Substitutes were easily found for shirt and shorts but no-one else's boots would fit his size 14 feet. Some kind soul at Spurs handed him ten shillings to buy boots. When word of this transaction reached the London Football Association the whole incident ballooned into a petty

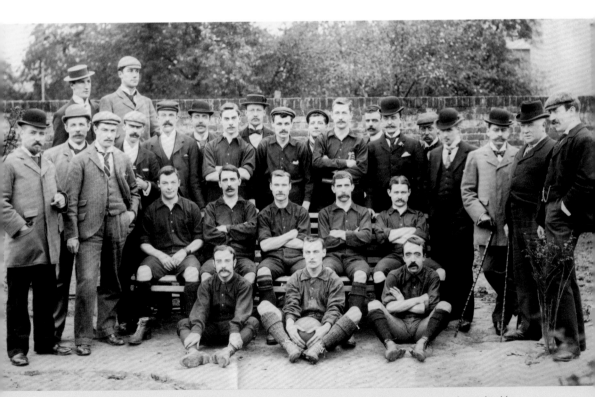

Team and supporters in 1895. Bobby on right of second row of players. Billy Harston sits in front of Bobby.

scandal. A solemn hearing was held a few days later and the club were held to have broken several rules including offering an unfair inducement. The club was suspended for a fortnight. An appeal was lodged but Bobby said later that he knew it would fail and he was right. At least Spurs were cleared of poaching Payne from Fulham who had denounced Spurs to the London FA. According to one source, Bobby admitted Spurs had got off lightly.

Spurs used the two weeks to practice but the whole affair shows how hard it was for an amateur club to maintain the semblance of amateurism when they were popular winners attracting large crowds to their Northumberland Park ground, which by now had a solid wooden grandstand, the first flimsy structure having blown down in the wind. There were proper, oil-lamp-lit dressing rooms in a dark cavity beneath 1000 spectators.

Let us pause for a moment to reflect that one single bank of seats at Spurs' new stadium seats over 17,000 fans.

Before the first wobbly grandstand the committee had lashed out on 100 yards of 6ft trestles to be placed around the ground "for the convenience of spectators" and spent less lavishly on ropes and stakes to keep the crowds off the pitch. In 1893, in order to provide a civilized space for the wives and girlfriends of players and spectators, an area was roped off. Members and their ladies got in free but others had to pay a penny. This penny paddock can be seen as the forerunner of today's luxurious hospitality suites.

Payne's Boots started a long drift towards professionalism which found Bobby embattled with bitter resistance. Professional football had been legalised in 1885, when Spurs were three years old. Northern and Midland clubs grabbed the opportunity. London and Southern teams clung stubbornly to amateurism despite having to contrive irksome ways to pay travelling and other costs. Richer players were more available to play than poorer men who could not afford time off work. Clearly unfair.

Bobby's thinking at this time was rammed home in a combative speech to the club's sixth annual dinner at the

Red Lion in 1891. He began by marvelling at Spurs' success. "I cannot help comparing the present standing of the club in the football world with their past history. As I have been a member from the start when we were almost all boys, I am in a position to judge their position." He declared that their "fondest hopes" of years ago had been "more than realised." Then he came to money. The boys had been fortunate in their backers, notably Mr Ripsher. "Because there was money we could get players. Where there was no money we could not."

Thus he prepared for the professionalism battle to come. With money "the club has gone on growing gradually" he said, while other clubs "came out like stars in beautiful colours for a time and just as suddenly collapsed." He boasted that Spurs' name "held good almost all over the South of England" but then he went back to the money theme. "Money is the thing that is wanted to secure the best players. The club that cannot pay the expenses of their players must go to the wall," he said, because the majority of good players were working men who could not pay rail fares to away matches and similar costs.

By 1893 Northern football was so far advanced that it dominated the South. The FA cast round for ways to respond to the allure of the professional FA Cup and came up with the Amateur Cup. Spurs signed up, but Bobby wanted more than a cup. He saw the future and it was professional.

Whether his audience at that dinner in 1891 fully grasped his obvious advocacy of professionalism there is no knowing. Certainly Bobby had to wait to get his way and even then it was a tough fight. He was not to know that when he got his way it would lead to bitterness in the coming years.

Shortly after Spurs' 13th anniversary things came to a head. Bobby attended a stormy meeting at the Eagle pub to consider going pro. The meeting went on for hours. Bobby proposed the change. The question had riven the club for months but Bobby said the players themselves were in favour of professionalism and the committee also agreed unanimously.

KEEPING THE BRIDGE.

A cartoon from the scrapbook highlighting the FA Cup, seen as a battle between North and South. Northern clubs dominated the Cup ... until 1901. Newton Heath is now called Manchester United, New Brompton now called Gillingham.

Questioned about the club's financial status, he said it owed £65 but that was covered by expected income from the new stand. Perhaps a little deviously he and other officers set their faces against turning the club into a public company. Loud opposition continued and Bobby and his colleagues were even accused of hiding something

shady in the books. But in the end and after passionate speeches and fearful forebodings, a vote was taken. Only one hand went up to vote against going pro although there were abstentions.

This was a triumph for Bobby and his friends. It is tempting to think that his slow, deliberate style of speaking that is remarked on throughout his life was persuasive and helped to carry the day. Certainly he must have put in many hours of persuasive coaxing to ensure a majority.

And while we are considering Bobby's oratory we should not assume that just because he was, as all witnesses agree, slow and deliberate, he was also brief. A report of the sixth annual dinner recorded how he was teased by another Spurs foundation member. Hamilton Douglas Casey who was down to speak after him but who could only say that "the lengthy speech of Mr Buckle has left nothing or very little for me to say." Was our hero, on this occasion at least, not only slow and deliberate but also long-winded? The minutes of a Spurs meeting in 1899 record that "Mr Buckle ... spoke at some length about the cup tie and the players' conduct generally." And again, in a report of a jubilant club dinner after winning the FA Cup in their first glory year of 1901, Bobby is recorded as giving "a long and detailed account of the history of the club from the time it first disported itself upon the Tottenham Marshes."

Back to the story. That summer the club managed to scrape together £140 as a reserve to pay players' wages next season. Since some footballers were by then getting over £1 a week, that kitty would not last long.

Thus Bobby was instrumental in the first of three great steps forward. The second was to sort out its financial future and become a company before the monumental move to Spurs' present home on the High Road as the third. The formation of Tottenham Hotspur Football & Athletic Company Ltd may be seen as a measure to contain the surging success of what had been a bunch of boys knocking a ball about.

This narrative is an attempt to explore the work of one half-forgotten hero. Readers must turn to the several fine general histories devoted to Spurs to understand the sheer

speed and scale of Spurs growth at this period. But we get the picture from the handwritten minutes of an emergency meeting of Spurs officers on 30th October 1898 when Bobby was instructed to write to the Great Eastern Railway asking them to increase the length of trains before a big match. Some cynics might argue that the railways still let Spurs fans down. Spurs had come a long way from that gas lamp gathering. Now for the second great leap forward.

Spurs had already become a business almost by accident. Their overwhelmed administration led to lapses like the failure to do something as basic as registering copyright of their own match-day programmes. These flimsy sheets had become the private perk of a Mr F.W. Andrews who, perhaps hearing that the Spurs Committee had belatedly empowered Bobby to register the copyright for the club, hastened to Stationers Hall in central London to forestall him. On arrival Andrews met Bobby on his way out having nipped out of his law office and completed the formalities on behalf of Spurs. Bobby did business the way he played football. At full tilt.

In this way, by trying to be alert and responding to events, Spurs managed to keep their runaway success on the road with the sort of measures his father might have used to control a runaway coach. Even so, it was not until two years after going professional that Bobby, by now entering his thirties, guided his colleagues towards becoming a limited company.

This possibility had been considered and resisted for many months but came to a head at a meeting at The Red Lion pub in the High Road on 2nd March 1898 when Bobby formally proposed creating a company and the motion was carried unanimously. He was elected one of five directors and they appointed a paid secretary-manager, John Cameron, who was to become Bobby's tormentor.

Perhaps it was Bobby's growing understanding of the law that made them realise the grave individual risks they had been taking. They were bearing personal liability for all manner of calamity and debt that would be laid at their

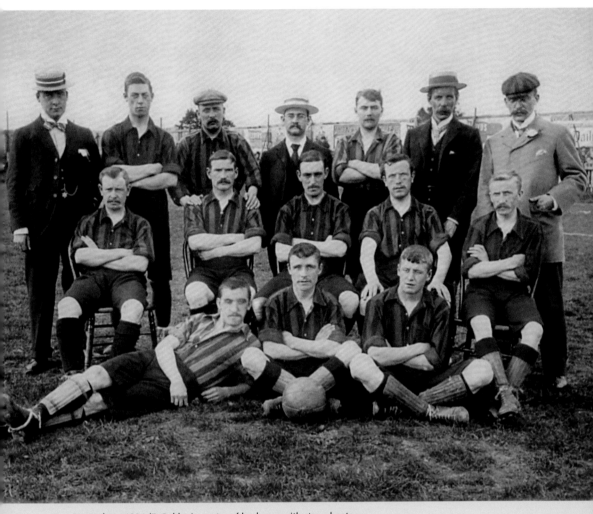

Team photo 1896/7. Bobby in centre of back row with straw boater.

door as they ran huge public events involving thousands of people. The club's rickety stands could collapse. It was time to take a serious step in self-defence if nothing else.

As with anything Bobby was involved in, things moved swiftly and only 31 days later a prospectus was launched offering 8,000 £1 shares with a sliding scale of voting rights depending on size of holding. Bobby's lawyer guardian angel and employer may have helped.

It is quaint viewed from this distance in time to read in the prospectus how Spurs proudly presented themselves as "one of the oldest Association clubs in London having been established 15 years."

Spurs was "sold" to the new company for less than the price of an average season ticket in the present stadium. But this new company was slow to attract investors. Even a major local employer like the Souths, who owned the White Hart Lane pottery serving the Lea Valley nurseries industry, did not buy a single share for over four years. This was despite the family supporting Spurs by letting the team use hay meadows for training and even at one stage giving football boots to poorer players. The founder's eldest son, Samuel South junior, went on to become a life-long friend of Bobby Buckle yet, like so many local people, was slow to stump up for shares.

Of the 1,000 shares only 296 had found buyers in the first campaign and of those two thirds lived outside the district. There was a frustrating gap in local loyalty. Spurs surged ahead as a public spectacle but the same public was reluctant to invest. Gates had doubled for three successive seasons and 14,000 were at a 1898 Good Friday home match with Woolwich Arsenal when so many spectators climbed on the tea bar roof that it collapsed and five people were hurt.

Clearly, Spurs had outgrown its Northumberland Park home with a capacity estimated at the time at an astonishing 30,000. If this figure is to be believed it is all the more surprising when we reflect that even now some Premier clubs can fail to attract that number.

It had not been until January 1896 that the committee first got round to wondering if they could in some way secure their position on the Northumberland Park ground. Bobby was in a deputation sent to Mr Pearl their landlord. They sought a tenancy for several years with a maximum annual rent of £100. But Bobby reported back that the possibility of buying the site had arisen. A week later he said a price of £4,000 had been set and the club had been given three months to respond. Today's fans may feel thankful

this initiative fizzled out but the experience was useful for Bobby who was soon to play a central role in a much more productive property negotiation.

During the financial crisis over the slow shares sales, there was a breakthrough in the ground crisis. It came just before the start of the 1898/99 season, and it was more by luck, idle gossip and a family tragedy that Spurs took another leap forward.

For the best part of half a century George Beckwith had been landlord of the White Hart in Tottenham High Road. George married a widow eight years older and mother of three deaf and dumb children. She also bore George a son. With six mouths to feed and disabled children to care for, he needed more money so set himself up as a nurseryman on the bit of rough ground behind the pub. He laboriously cultivated the land to grow vegetables, fruit and flowers which he sold and also helped other growers market their produce.

This busy man died in 1898 and Charrington found a new landlord who saw a completely different way to make money out of that well-tilled earth behind the pub. He came from Millwall where he sold a lot of beer to football fans and reckoned he could do the same if only there was a club with thirsty fans to watch games on new turf laid where poor George had laboured long. No-one had told him about Spurs.

Somehow an unnamed apprentice cooper happened to hear about this plan, perhaps in a chat over the bar. This anonymous trainee barrel maker, who should be seen as another of Spurs' inadvertent benefactors, happened to mention the landlord's plan to Charles Roberts, chairman of the Tottenham Hotspur board.

From this point, and in stark contrast to the shares sales, things moved at breakneck speed. Roberts instantly recognised the opportunity that had fallen in the club's lap and equally quickly turned to Bobby for action. Next day the two men were at the offices of the pub's owners, Charrington, one of the capital's biggest brewers. They were seen by two directors. Bobby and his chairman outlined their vision for the land behind the White Hart. It was the

perfect place to play football to large crowds. In response, the Charrington's directors outlined their vision for a huge housing estate of the sort that had already swamped large tracts of Tottenham around Bobby's White Cottage home just across the High Road from the pub.

Bobby's job now was to help Roberts convince the brewers they would sell more beer to thousands of football fans than they would to hundreds of new householders. The Tottenham Hotspur argument was a telling one. They pointed out that allowing football on their land would cost the brewers no capital outlay, unlike building houses.

By the end of what could be seen as the second most important meeting in Spurs' entire history, second only to when those boys assembled under a gas lamp, the brewers

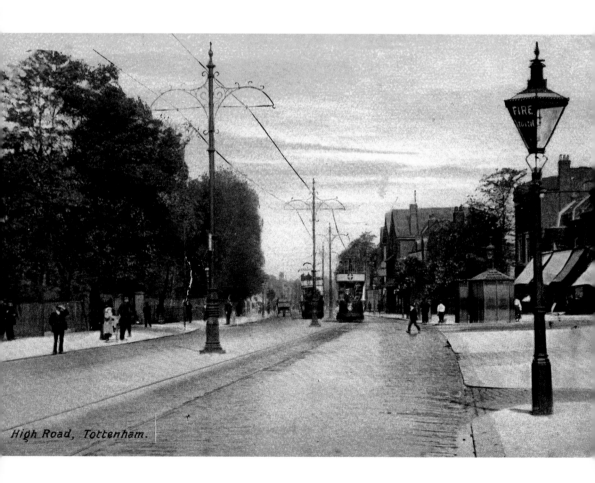

High Road, Tottenham.

were divided. One wanted Spurs, the other stuck out for housing. Bobby and Roberts withdrew, fingers crossed, relying on the football supporter to make the housing supporter see sense. And he did. Charrington agreed to let Spurs use their land although there was an almost comical hitch in the negotiations when the brewers sought a guarantee of minimum attendance at games. Fortunately they were as ill-informed about Tottenham Hotspur F.C. Ltd as the landlord of their pub. Bobby found it easy to assure them that matches would be attended by at least 1,000. He knew that the club had by then reached such heights of popularity that 1,000 would be regarded as an impossibly low gate. So for £100 a year Spurs became tenants of part of the site today's stadium straddles. The lease was set to last for 21 years and Bobby played a major role in this but it was extended and changed in 1905.

According to the minutes of a board meeting on 21st November 1898 "A vote of thanks was unanimously passed to Mr Buckle for the excellent manner he had got the lease of the ground passed and for his trouble in doing so."

The club made a handy sum to develop the new ground by selling the remainder of their five-year lease on the old Northumberland Park ground. That money was needed because, apart from all the other aspects of creating a football stadium, the lumps of concrete that had been part of the nursery buildings obstructed George Beckwith's good earth and had to be cleared.

They had four months to get White Hart Lane ready for the 1899 season and set to take a projected capacity of 25,000 spectators. The old wooden stand at Northumberland Park was dismantled and re-erected at what was by then being called White Hart Lane. The club had wondered what to call the new ground but it seems they never reached consensus. So far as we know they never took a vote; somehow "White Hart Lane" just emerged in everyday talk and then somehow stuck, largely because most club correspondence had been conducted on headed paper from Bobby's home at White Cottage, No. 7 White Hart Lane. The outside world would have been familiar with the address. And even now, after the club

OPPOSITE
The spot under a High Road gas lamp where a bunch of boys created Spurs one magical August evening in 1882 has become almost sacred to fans. Or it would be if we were certain where it was. This is the best bet. In the right-hand foreground of this c.1904 post-card we see a lamppost where Park Lane meets the High Road. Long vanished, it stood on the homeward route of Bobby and his pals in high spirits after a successful match on the marshes. It was also an obvious place to pause and chat before their ways divided. Bobby would have turned right and passed where today's stadium stands. That route would also have taken him past a second lamppost competing for foundation fame. It is glimpsed distantly on the left close to the Church Road junction. Pilgrims in doubt are advised to visit both locations to be on the safe side.

dropped it from their style, White Hart Lane remains the name used by fans and media. It lives on in that cocky chant "We are Tottenham, Tottenham from the Lane." So it was at White Hart Lane on 2nd September 1899 they played their first match, beating Notts County 4–1 in a friendly before a crowd of 5,000.

Their first groundsman, John Over, was a fanatic allowing no foot to be set on his sacred space between matches. Jokers said he combed the blades of grass. Something of this devotion to turf seems to have rubbed off on Bobby as we shall soon discover when we find him as a settled family man in South London.

Since, as already acknowledged, there are several excellent histories of Spurs, there would be little purpose in naming the many key figures with whom Bobby had dealings in the early days unless they illuminate his character.

Such a figure is John Oliver. He was a slightly mysterious money man to whom the pragmatic Bobby and his fellow committee members turned when our infant club was in dire financial need while still amateur. The sums involved were miniscule by today's measure but at that stage Spurs were often only a few pounds away from being unable to balance the books. Bobby may have been devoted to respectable solvency but he bent over backwards to achieve it by associating himself with Oliver.

When Bobby became secretary of the Southern Alliance in 1895, he would have met Oliver, the chairman. Oliver was a furniture manufacturer, sometimes described as a carpet manufacturer, who prospered as empty new homes mushroomed around the capital and needed filling with wardrobes and what-nots. So it was to Oliver and friends that Bobby turned to save Spurs.

Typical of his type and his time, Oliver enjoyed cutting a dash in the community and its phenomenal popularity must have made football an ideal stage on which to strut. Spurs were a runaway success as crowd-pullers so, as a committee member and then president, the club was a perfect fit for Oliver. Spurs benefitted hugely too, but sometimes in ways that would have raised eyebrows at

the FA as it sought strict enforcement of pure amateurism. Spurs' problem was that their income did not reflect their fame which was based on good football players who were effectively subsidising the spectators' entertainment with their own money. Lost earnings and travelling expenses could drive away a poorly-paid player. But the club were forbidden to pay.

Along comes John Oliver who advances funds and finds a legitimate way round another problem by employing team members at his factory on favourable terms that allowed time off for matches and training. This relationship seems to have enabled Spurs to get by well enough until the famous meeting at the Eagle on 20th December 1895 when, with Oliver as an enthusiastic chairman, Spurs formally went professional and such ruses were no longer needed.

Much later, after Spurs had become a limited company, Bobby heard that calamity had befallen Oliver. According to different versions of the story he was declared dead or merely bankrupt. Bobby's response was an example of steadfast loyalty. Bobby wanted to assist Oliver or his widow just as his former fixer had helped the club. But this noble impulse hit a snag. Any direct payment out of Spurs funds would show up in the club's accounts. This might alert the FA and attract retroactive punishment for Spurs. Memory of the Payne's boots scandal still hung over them.

The way out of this problem was for Bobby and his colleagues to organise fund-raising events. There is a record of a "testimonial match" for J. Oliver in January 1901. A month earlier a newspaper reported that Oliver "has recently hit hard times." Later in January another newspaper referred to "the late Mr John Oliver" and the Sporting Life says the testimonial match was "to help Mrs Oliver and her children." The idea that Oliver was dead must have come from the phrase "Mrs Oliver and her children" implying she was a widow. However someone with knowledge of business, bankruptcy and the law had chosen that phrase for a good reason. Had the proceeds gone straight to John Oliver they might have been claimed by his creditors and

never have reached his family. We can only guess who that "someone" was but the ruse appears to have worked. However, the affair was not over. It was merely festering under the surface.

No year was happier, busier, prouder or more ominous for Bobby Buckle than 1901. He married. He left Tottenham. Spurs won the FA Cup. The club honoured him. Yet it is possible to detect the early signs of disillusion leading to alienation in the way he sees Spurs.

The year began with an ending. The Old Queen died in January. The vast Victorian Empire had just set foot in a changeful 20th century. In his little world, change was all Bobby had ever known. Since childhood he had seen his local landscape change from countryside to town. By 1901 the stadium he had helped create held a little square oasis of green among the ceaseless lava flow of houses, factories, offices and shops creeping over the meadows and market gardens. Small wonder his bride was eager to move to a posh new suburb in her native South London. But exploring the significance of that move and Bobby's life as father, grandfather, trusted businessman and churchman must wait while we try to solve a mystery that has dogged his friends and family for over a century.

In this momentous 1901 when Spurs first won the FA Cup a great celebration dinner was held in Holborn, central London, and Spurs turned to orator Buckle to propose the key toast to the club. From what we know of that splendid occasion Bobby made one of his famously lengthy speeches devoting a good deal of it not to extoling the Spurs of 1901 but reminding his audience of how it all began. He talked not so much about how it was organised in those early days as about who played and how they played. In the light of what we now know was to happen in the next five years, talking about football and footballers would fit what was to become his favourite theme. Boards, bigwigs and balance sheets came second to his vision of the game, a vision born on the marshes of sportsmanship, stylish football and team spirit. Those for Bobby were Spurs' glory, glory days. Now, something seems to have

COCK-A-DOODLE-LU-TON.

Cartoons using a cockerel to portray Spurs, over 20 years before it was adopted as its official logo

been irking him. That mystical brotherhood of the marshes was slipping away.

For years he had championed change, fought for change, won change. He was at the heart of the three monumental changes – professionalism, incorporation and the stadium – that had created the triumphant Spurs of 1901. Was it all working out the way he had hoped and intended?

By this time Bobby, on the brink of marriage and moving away, had severed almost every formal link with Spurs but his small shareholding still gave him a voice he would come to use aggressively.

Bobby played his last match for his beloved Spurs at the end of the season in 1900. It was surely an emotionally charged event. He was not alone in feeling the weight of that moment when for the final time he slipped on the shirt he had helped to create. The end of season Old Crocks game was as much a social event as a serious match. A photographer had been summoned and no-one wanted to be left out of the picture, on the day the great Bobby Buckle was hanging up his boots.

The resulting photograph (turn to page 84) bears close study for there is every reason to believe that, setting aside those with Ethel on his wedding day, this was for Bobby the most important photograph of his entire life.

Because it was a day when anyone who had ever played in the first team could join in, we find not only some of his dearest and oldest friends from the Marshes but stars of the current season like Sandy Brown, the great goal scorer who would next season steer Spurs to the unassailable heights of being the only non-league side ever to win the FA Cup. In the photograph this celebrity takes centre seat complete with ball. There, too is director Tom Deacock taking a modestly remote spot on the far left of the back row. Secretary/manager John Cameron, a little more pushy, is in there with the footballers and standing right behind Bobby who sits on the right of the centre rank beside his dear friend Ham Casey. Another steadfast pal from the earliest days, Jack Jull, the long-serving Spurs captain, sits at the far left of the front row.

A cynic might suggest Cameron's position behind Bobby was ideal for a man who before long would figuratively stab Bobby in the back. In a sense this single image encompasses the Buckle story from gaslamp to goodbye.

At the annual meeting in 1900 and despite every effort made by his colleagues to induce him to reconsider Bobby refused to stand for re-election as a director. Minutes, compiled by Cameron, solemnly recorded that this was "deeply regretted" by the other shareholders. Soon these two men quarrelled bitterly and the Oliver affair came back to haunt them.

Here we reach what could be seen as a crucial and sometimes dramatic period in the Bobby Buckle story. He was off the field but embattled in ferocious defence of a friend and of football. For all his courage, skill and speed as a winger, it was on the formal battleground of annual meetings that Bobby now shone as a fighter. There was no mud here but a good deal of mud-slinging. He made enemies when he won but he did not always win. Bobby would probably come to see these years as an overall defeat.

Bobby attended the club's 1901 annual meeting as a shareholder and his only interventions seemed innocent enough. He paid a few compliments and with characteristic concern for footballers as the most important people in the club, urged the directors always to pay them as highly as they could. "It is in the interest of big clubs like Spurs to pay high wages."

Then he mentioned Oliver and, on being told that his benefit match held in January that year had raised £120, proposed a motion that the directors should make him a substantial grant out of club funds. "Not many people are aware of how generous he had been to us," he said. Perhaps surprisingly in the light of what was to come later in the Oliver affair, the motion was carried. The chairman said the board had already considered Oliver's plight but thought the remedy should be for shareholders to decide. So how much was Oliver to get? Bobby said: "The money given by Mr Oliver did not fall far short of £500" but he

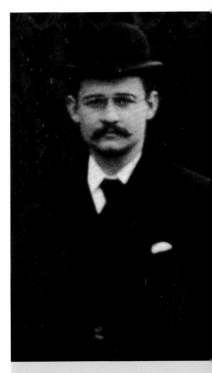

Evidence of Bobby's sartorial elegance: bowler hat, city coat, top pocket handkerchief and a fashionable moustache

cautiously proposed only £150. The meeting decided to let the board decide. So Bobby won in principle but it is unclear if his old friend ever actually got that money.

(As an aside it is illuminating to note that at the same meeting the dire financial plight of Millwall F.C. was discussed. It was agreed "it would be a calamity for Spurs if the club fell through" and so Spurs invested in Millwall shares to help tide them over the crisis.)

Fast forward to 1904. Despite having swayed the board and shareholders in Oliver's favour, it is clear Bobby was unhappy with the sort of people now running things. He was a footballer's footballer. They were businessmen, not footballers. Prosperous and greatly respected local notables totally committed to Spurs but, in his eyes perhaps, lacking the total commitment to football that had been his guiding star ever since he first kicked a stone down the High Road.

The meeting at Bruce Grove Board School began with a review showing the highest ever revenue at £10,186, but correspondingly high expenditure of £9,508, much of it on new players after a shaky start to the season. They had ended second in the Southern League. Success had been bought. Or so it seemed. Not all shareholders were happy with this and Bobby complained that an "abnormal sum" had been spent on special training, double the previous year's.

Later he protested at "gross extravagance." "The money paid for players was practically wasted," he said. The team's recovery from a bad start was "absolutely down to the old players." As for the special training, he asked: "Is it not extraordinary that seven weeks after the commencement of the season and after the men had had their three months' holiday they should need to be sent to the seaside? Then when they came back from Leigh they went on playing the same as before."

Then Bobby, who clearly had been doing his homework and came armed with statistics, lobbed another grenade from the touchline. This time it was against high travelling expenses to matches. "Last season Arsenal travelled 1,300 miles more than the Spurs for £30 less."

Heckling broke out. Some for him, some against. He pressed on: "It's easy come, easy go. If this policy continues the club will absolutely go under."

The chairman, the same Charles Roberts with whom Bobby had worked so closely in the leasing of their ground, snapped back: "If the directors had pursued the policy advocated by Mr Buckle it would not be in the position it is today."

Undeterred, Bobby went into battle on a much more personal issue when it came to the election of directors. He spoke against the re-election of two retiring directors as "not in the best interests of the club and therefore I will propose as an amendment that Messrs J.C. Jull and H.D. Casey be directors in their stead." Jull and Casey! Names from the past. Names going back to the marshes and gas lamp days. Friends, footballers rather than businessmen.

"Before I saw the balance sheet I had no idea of making such a proposal," he declared, "but now I can see some change is needed. Mr Jull is a former captain of the club and Mr Casey is a referee. Both are experts in the art of football and that is what the directorate needs now. Footballers, pure and simple are needed to assist in the management of the club." When accused of repeating criticisms he had made at earlier meetings Bobby quickly replied that this only proved his consistency. It was time they got two practical footballers on the board instead of what he called "a social party."

For all his eloquence and fury, Bobby lost the vote 106–73. The bitterness lingered. One of the two re-elected directors, Mr Deacock, said he "felt very much hurt" by Bobby's remarks about knowing too little about football and footballers and added the bitter words: "Since his retirement Mr Buckle has done nothing but bicker about the management of the club and pull it to pieces on every possible occasion." When Bobby left the meeting it must have been in a state of anger and frustration. He feared for his club, he feared for football. He had failed not only his friends but football itself – the "art of football pure and simple."

It is possible to see in this sad night for Bobby a hint of where not just Spurs but the entire game was going. A gulf was growing between the ground and the boardroom. Fewer and fewer would cross between the two in future. Bobby had glimpsed the future and he did not like it.

If the annual meeting of 1904 was a serious setback for Bobby, the meeting a year later was disastrous as the John Oliver affair emerged yet again. An extraordinary meeting of shareholders was called before the main meeting. Its purpose was to take £150 out of Spurs funds and give it to John Oliver "in consideration of the great financial and other services he had rendered to the club." He went away empty-handed after rancorous exchanges. There had been a complete somersault in attitudes to Oliver. Had someone perhaps pointed out that the company could not settle undeclared debts incurred before incorporation?

Oliver himself was there to endure cheap jibes from angry shareholders suggesting he should get his money back from the amateurs paid illicitly in the past. Inflammatory questions were asked about what happened to the gate money in former days. Oliver said he never touched it and Bobby testified that gate money went on current expenses.

In a key intervention supporting Oliver and defending the illicit payments Bobby said: "Of course it might be said in the present day that the things we did were very wrong things to do and undoubtedly they were in the eyes of the Football Association, but at that time we were living in a different atmosphere to that of today. Nearly all the so-called amateur teams of the day were doing the same. No-one on the management committee had any idea of getting anything by it. We wanted to get a team in Tottenham that would hold its own anywhere in London." Here again we see Bobby's curious combination of idealism and pragmatism.

Bobby said that, like the others, he had himself paid his "little bit" to "certain players' 'expenses' as they were called." But most came out of John Oliver's pocket. Then Bobby fired his final dart at the company saying that had it not been for Oliver the company would not exist

because the club would not have existed. In short Oliver had saved Spurs.

After further heated exchanges, the club fired back its own dart at Bobby in the words of John Cameron, the man who replaced the unpaid Bobby as paid secretary: "Mr Buckle does not know anything about the inner workings of the club now." Then he added another low blow: "He is going back to the days when he was associated with football."

How those words from Cameron, the man whom Bobby had voted into the job, must have stung. Bobby, the man who had helped to steer the club all the way from the marshes and the lamppost meeting to popular success, professionalism, incorporation and a splendid stadium to be told: "Mr Buckle does not know anything about the inner workings of the club now." And then the extra jibe about "the days when he was associated with football." Later in his long life Bobby would suffer calamity – the death of children, personal injury – but this was his first serious crisis. He was becoming an outcast in his own club.

Was this the turning point? Bobby had become increasingly critical of the way the club was run but was this the moment when, privately if not publicly, he began seriously to turn his back on his own boyhood brainchild, the club he had created, the club he loved?

In the space of a single evening he had lost the attempt to compensate the man who, to his mind, had rescued Spurs and he had been insulted by a man paid to do the job he himself had done for nothing for more than ten years.

Of the two outcomes of the evening, Cameron's words bit deep but failure to help Oliver may have bitten deeper. The exact relationship between Buckle and Oliver is hard to pin down but in a 1895 group picture they sit side by side and there is no reason to suppose they ever fell out through all the businessman's adventures, especially as Bobby called his first-born son Oliver.

One way of looking at Bobby's role in all this suggests two sides to his character. First, he was prepared to ally himself with a man who was ready to bend the rules in

an impeccably good cause and, second, he stood by his man and believed Spurs owed him a debt of honour. Which leaves us to speculate on how his conduct fitted in with his Christian belief to which, as we shall see, he clung until the end.

But, above all, those bitter annual meetings, calamitous as they were for him, give us a glimpse of what football meant to him. "Pure and simple, the art of football" – words of almost religious devotion. Bobby Buckle did not see football as just a game. It was the magic of men exercising civilized skills in what he loved to call "pretty football." His was an almost Olympian vision that did not sit easily in a room full of successful shopkeepers. His football was drifting away from him and he cannot have failed to wonder if it was his own fault. He it was who agitated for professionalism, for incorporation, for a costly stadium. The earnest endeavours of his lads long ago were lost now in the marsh mists. Football pure and simple was dead. And who shared the blame for that?

This tussle between faith and football, loyalty and the law, may have given Bobby a few sleepless nights.

A Stranger to Tottenham

We return now to 1901, that momentous year, the year when the Old Queen died, Spurs, to which he had devoted 19 frantic years, won the FA Cup in April and then in August he walked down the aisle of All Saints, Edmonton with Ethel, whom he had met as a schoolgirl on the daily train from White Hart Lane. Bobby should have been walking on air but, as we now know, something was unsettling him. We cannot blame his bride. They were a devoted couple and she had always been the most devoted of Spurs fans. Ethel can be seen as a pioneer "WAG" since she often turned up to watch Bobby play long before they wed. Yet it is from this time, long before the bitter battles of 1904 and 1905, that we see him beginning to distance himself from the club he had helped to build from that legendary gas lamp meeting.

Those were the days when husbands ruled the roost and at about the time of the wedding Bobby told Ethel to stop keeping her Spurs scrapbook. She obeyed but the book, through her gentle defiance, has survived in the family. Her interest never lapsed or even faded. So we cannot blame Ethel. We may get hints of what went wrong by looking at a few figures from that time in his life.

When Spurs won the Cup that year they were the first and surely the last non-league club to do it. Bobby's local pride would have been hurt that none of those triumphant Spurs players came from London, let alone Tottenham.

Earlier, when he helped engineer the sale of Spurs shares, we can imagine his dismay that only a third of the first takers came from Tottenham. Did Bobby feel that ownership of "his" club had left Tottenham for ever?

In a single stark sentence in their excellent "People's History of Tottenham Hotspur Football Club," Martin Cloake and Alan Fisher declare that after the company launch "Never again would local people and supporters have a chance for a significant involvement in the running of the club." Yet he also put down new business roots in the very streets on which he had turned his back and was still seen at Claremont Street Baptist Church where he was part of a network of professionals and businessmen.

This gloomy view is the plain truth although it is worth recording that Tottenham people, even if they lacked power, remained committed to their club. For example, when the pitch became waterlogged Bobby's pal Sam South provided cartloads of broken plant pots from the family factory to act as a drainage layer under the turf. Alas it failed until more drastic measures were taken. And, of course, local supporters were always the backbone of the fan base.

When Bobby took what would even now be the momentous step of moving South of the River, buying a fairly large and comfortable house in Colliers Wood where he would spend the rest of his life, was it just to get away from Tottenham where he had begun to feel a stranger in his own club? Or was it because his bride wanted to be near family members living in that strange territory where North Londoners hesitate to stray. For her it was home territory.

Another persuasive possibility is that this ambitious citizen of the Edwardian age wanted to better himself in a middle class suburb even further from the muddy Suffolk furrows plodded by his penniless ancestors and from the increasingly urban atmosphere of Tottenham.

Such a mixed picture of our hero's attitude to Spurs emerges over the years. He happily accepted a thank-you canteen of cutlery from the club in 1898, having played his last competitive game in 1895. But he played in an Old Crocks game in 1900, setting foot as a player on John Over's sacred sward, and ran the line at a Charity Shield match at White Hart Lane in 1902.

The break was far from complete. He was still so respected that, as we have already noted, he was the man

to whom they turned to propose the toast to the club at a splendid dinner to celebrate the FA Cup win in the grand setting of the King's Hall restaurant in Holborn.

Spurs has never been a club to do things by halves and they had held an earlier grand dinner just to celebrate winning the Cup semi-final. Bobby was summoned back then to say the right thing and to entertain the happy company using a talent he had honed as a lad guided by the Baptist hymnal. He sang them a song.

Compare these events with his remarks at the age of 84 to a newspaper reporter at the time of his Golden Wedding in 1951. "I maintain that with the same team today we could beat anybody," he said of the Spurs line-up that won the Cup in '01, but he also claimed that after leaving Spurs he never saw another football match. Can this be true? Was he serious when he told a reporter in 1923 that "I wouldn't now cross the proverbial road to see any football match"? Some in his family believe he could not bear to watch football of a standard beneath his own. If he was serious, why did he sometimes ask visitors for news of Spurs? And if he did want to forget and be forgotten he failed totally. Whenever the name Robert Buckle turned up in some form unrelated to Spurs he was immediately reminded he was a famous footballer.

A curious case of this arose in 1923 when for some unexplained reason he was called to give evidence at a Ministry of Health inquiry. A newspaper commentator ignored the purpose of the inquiry to concentrate on our man. "Mr 'Bob' Buckle came into the limelight of publicity last week though in an entirely different connection to football." And of Bobby's evidence the writer says: "As in the days he brought the Spurs club through doubt and difficulty, he showed his business brain. Another old Spur present at the inquiry tells me it was just like listening to 'Bob' explaining the pros and cons at a committee of the Spurs club years ago." The newspaperman then wrote something that underlines the solid esteem in which our man was still held long after he left the scene: "If there had been no Mr Robt. Buckle," declares the writer, "there might have been no Spurs club today."

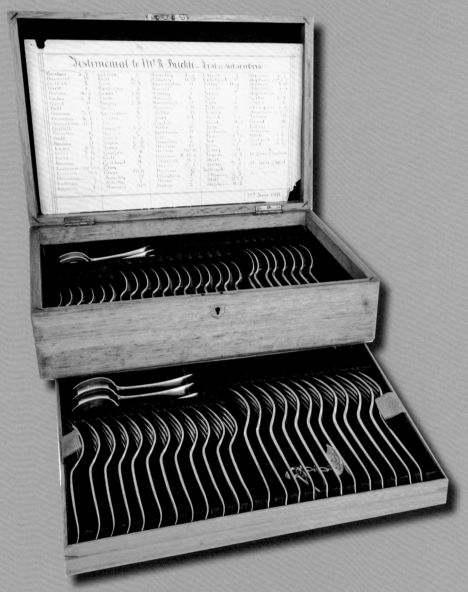

The presentation canteen

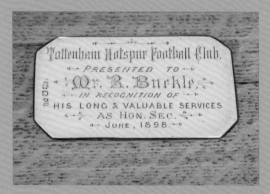

That passing mention of his "business brain" brings us to what could be called the rest of Bobby's life and it still holds some surprises. As football and Spurs ceased to be his main obsessions Bobby retained three serious sides to his days: family, faith and work.

To start with the last, Bobby clearly worked his way up at Pedley, May & Fletcher where he was always under the eye of the kindly senior partner who had seen him through grammar school and given him the job as he had given Bobby's father a job all those years ago.

At first his role of solicitor's clerk was very lowly indeed but it is worth noting that, according to a contemporary study, although the whole race of clerks were "on a level with artisans, earning £75 to £150 a year, socially and economically they were on an entirely different footing." The study goes on: "From top to bottom clerks associate with clerks and artisans with artisans ... A clerk lives an entirely different life from an artisan – marries a different kind of wife – has different aims and different ideas, different possibilities and different limitations ... It is not by any means only a question of clothes, of the wearing or not wearing of a white shirt every day, but of differences which invade every department in life, and at every turn affect the family budget. More undoubtedly is expected from the clerk than the artisan, but the clerk's money goes further – is on the whole much better spent." This analysis is borne out by studying Bobby's appearance in Spurs team shots. He may not have been the best off but he was the best dressed.

So our man is already a very long way from the Suffolk clod-hopper with whom we began this story.

In those first days in the daunting City offices he was probably little more than a "gofer". Early in that century when Charles Dickens was a solicitor's clerk he ran errands, delivered documents and, significantly, kept the petty cash fund. Being trusted with money seems to have been Bobby's forte. Much later he is officially labelled as a solicitor's bookkeeper. This may sound a dull job but was crucial to the entire firm. An 1884 handbook for solicitors' bookkeepers states boldly that "To have the book

department neglected is, in many instances, the cause of ultimate failure, if not disgrace." So at the peak of his professional life Bobby held his employers' prosperity in his hands. It was Bobby who billed clients, calculated costs and profits. The great men upstairs made wise decisions and handed out advice, fought cases and saved fortunes, while never mentioning money. Money was what Bobby dealt with downstairs.

At some time he must have become so trusted that he was allowed to operate an insurance franchise in the office. He became the agent for at least one company and sold life assurance and other policies from which he would have drawn not only the original fee for securing a new client but annual fees for as long as the policy continued. Over the years this trickle must have become a steady stream of money, perhaps even more than his modest

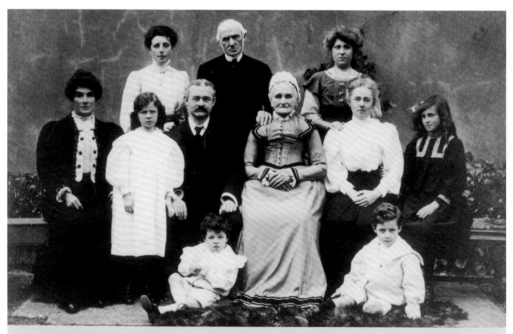

Bobby's parents Golden Wedding in 1908. Bobby sits next to his mother Emma, with Ethel behind next to Ebenezer. Next to Bobby is his eldest daughter Hilda with Bobby's sister Emma on far left. Sons Maurice (left) and Oliver sitting. Bobby's sister in law Christinia Buckle, and her daughters Edith and Gladys to the right of Bobby's mother.

clerkly pay. After all, a solicitors' office where so many people are settling their affairs must have been an ideal place to sell policies. "May I suggest you see our Mr Buckle about that?" Ding! And another sum falls into Bobby's till.

What Bobby did with his good fortune and how his wife played a curious role in his financial affairs must wait while we explore 6 Wilton Road, Colliers Wood and the lives lived there.

When Bobby bought "Rosslyn," a substantial double-fronted, four-bedroom house in a leafy Surrey suburb on a 99-year lease, he quickly found Ethel a live-in maid to help her make a home. This was Surrey-born Minnie Akers, who was the same age as Ethel but died a spinster after many years in the Buckles' service. She saw the family grow as Ethel bore eleven children of whom eight survived infancy. Although No.6 Wilton Road is large enough to have been converted into its present five flats (the largest of which was worth £500,000 in 2019), it must have been bursting with children, parents and servants in the early 1900's.

When Bobby was 42 and Ethel 33 they had four surviving sons and one daughter, for each of whom a live-in maternity nurse was employed at first and, more permanently, the household included a governess. This may sound grand but was in fact thrifty. Employing a governess was cheaper than paying school fees and seems to have done the children no harm when they went to secondary school.

Each morning Bobby joined an army of clean-white-shirted clerks from Tooting, Wimbledon, Balham and Merton across the river to their daily desks. Each evening Bobby returned to his chair by the parlour gas fire looking out on the garden through the stained-glass windows of the conservatory. This pattern persisted through two world wars. We do not know how Bobby served in wartime as ARP warden, fire-watcher or some other civilian role. His absence from the armed services can only be attributed to his physical failings. His eyesight had always been poor and we know that he became increasingly lame. In the grim 1940s he made the daily journey through blacked-out streets to a blitzed and sandbagged City where his Cannon Street office was bombed out and had to move to another nearby.

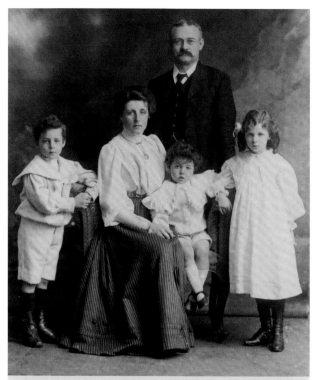

Bobby and Ethel family photo in 1908 with children
Oliver, Maurice and Hilda

While waiting for his supper he would have put his head into the playroom just to the left of the front door to see his growing brood some of whom would have spent the day studying there. Strangely, this inevitably noisy room was where the telephone (Liberty 4989) was installed. It remained the playroom long after his children had children of their own and visiting grandchildren dived behind a black curtain to find the toys shelved there.

As the years passed at Wilton Road, Bobby, Ethel and their children played a classic role in English social history. Generation by generation, as they shook any last traces of Suffolk soil from brightly polished boots in smart suburban streets, their status rose rung by rung. Not all survived to see the family prosper. The death of children was a fact of

life. Of their eleven children two of those who died
as infants, Bernard and Edmund, lived long enough to
be named.

As for the survivors of their early years, they all
started their education at home and it is a positive tale.
First-born Hilda trained as a shorthand typist, became a
secretary at a City shipping company, met her husband at a
Midland Bank social event she attended with her brothers
Oliver and Maurice, who made careers in banking. Eldest
son Oliver ended up managing the Midland's Worthing
branch while Maurice presided at Forest Hill.

The Buckles' son Roger started as a commercial
traveller, selling ceramics, but his wife's family helped
to establish him as a licensee and he ran The Eagle in
Southampton, served as senior fireman in World War II
then ran pubs and hotels in Weymouth and Botley.

Another daughter, Marjorie, trained as a PE teacher
and later ran her own school of English for foreign students.
Her son, Christopher, later briefly taught there. Nora
followed the family's new tradition and worked for the
Midland Bank branch in Pall Mall.

The fifth and final surviving son, Pilot Officer Leonard,
served as aircrew in the RAF in World War II and spent the
rest of his working life in local government, finally rising
to Chief Rating Officer in several big London boroughs.
His ability to collect money would came in handy when
he helped his mother gather Tottenham rents as we shall
shortly learn.

Could their dirt-poor forebears ever have imagined
such life stories in their family? But, as we know, such a
transformation was typical of the times.

The abiding memory of their grandchildren is of
Bobby's obsession with his garden. An accident boarding
a bus had left him lame and then, some time later, he
had a fall at home injuring a hip. Despite being left with
a painful hip nothing stopped him gardening. Geraniums
were his favourite flowers but he was fanatical about his
lawn. Perhaps Mr Over, the equally fanatical groundsman
who created the first White Hart Lane pitch, started Bobby
on his perennial search for perfection. At times children

No. 6 Wilton Road, photo from Ethel's album

were forbidden to set foot on his grass or even roll down its gentle slope. He so hated worm casts that he sometimes purposely flooded the turf to force the worms to the surface where he collected them in a bucket and they were never seen again. "If a thing's worth doing, it is worth doing well" he always wrote when children asked him to contribute a motto to their autograph books. But he may have been a little too thorough with those highly valuable, industrious and unfortunate worms. Even worse, he then tugged a heavy roller over his precious lawn. Yet everyone agrees it survived to be his pride and joy.

Even in his 80s, hobbling about with a stick, he continued gardening although after the fall he slept downstairs closer to his pampered lawn.

With Bobby busy in his garden, Ethel was even busier indoors. A brilliant needlewoman, she for years made all her sons' and daughters' clothes and in her spare time supplied chapel sales of work with yet more items.

If Bobby ran a rather straight-laced family, they had their fun. They would hire a charabanc to take them all off for seaside holidays most years and played cricket, not football, on the beach. Bobby also devised a beach game in which he would stand at the centre of a circle of children and use a tennis racquet to whack a ball high into the sky. Only at the last moment as the ball was hurtling down would he name the nervously waiting boy or girl who had to catch it. Sport was serious fun with Bobby in charge.

Christmas was the time for a huge family reunion with up to 30 at table. The poultry was plenteous and came from a client of Pedley, May & Fletcher. The gift was almost certainly intended for the partners but so valued had their bookkeeper become that he was always included

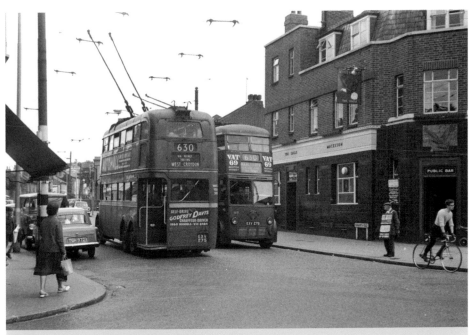

Trolley buses in Tamworth Road, Croydon

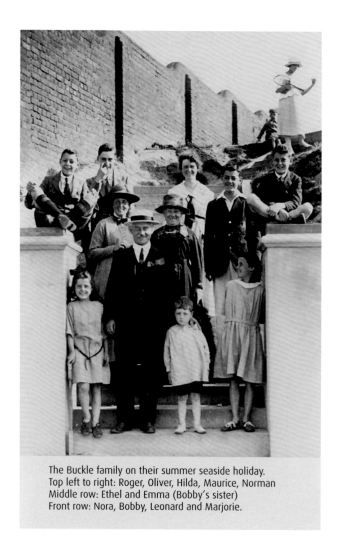

The Buckle family on their summer seaside holiday.
Top left to right: Roger, Oliver, Hilda, Maurice, Norman
Middle row: Ethel and Emma (Bobby's sister)
Front row: Nora, Bobby, Leonard and Marjorie.

in the distribution of duck, geese, turkeys and the rest.
Bobby carved but only after saying the grace that preceded
every meal be it feast or snack. For this he used the same
oratorical style he had used to sway Spurs meetings. His
daughter Mary says it went: "For what (long pause) we are
about (long pause) to receive (long pause) may the Lord
(long pause) make us truly thankful." Some of his multitude
of grandchildren on these occasions found him a little
forbidding but he did his best to please them by challenging
them to his favourite parlour game, Chinese chequers. It

reflects his untamed competitive spirit shown as a speedy outside left long ago that he never, ever let them win.

One of these grandchildren, Eleanor Kerrigan, paints a vivid picture of the man she knew when she was a little girl.

"At age seven I was lucky enough to stay with Grandma and Grandad for a month. At that time Grandad would have been coming up to age 81 and was still working but I'm not sure if it was every day or only part time. When he did go to work Grandma and I would go to Colliers Wood underground station to meet Grandad. A station worker used to take me down the escalator and back while we were waiting. Sunday and Thursday evenings were times Grandma and Grandad went to chapel at Croydon. We had to walk quite a long way to catch the bus there. Sunday afternoons we all sat quietly in the sitting room and Grandma used to read or sew. I think Grandad probably had a little snooze because I was given Bible texts to colour in and had to be very quiet. Occasionally I was given a chocolate."

But there was one sweet he was never known to share. This abstemious grandfather had an addiction. It was to Callard & Bowser's butterscotch. So we are left with the abiding image of a once-great athlete, now gruff, old and bald, limping to his chair by the fire encased in shirt, tie, and three-piece suit to suck toffees. Perhaps he sometimes glanced down at his high, black lace-up boots, remembering how he so upset his mum by kicking stones down the High Road as a little boy. Unchanged through all those years were his bright blue eyes that people had remarked on throughout his life in football fields, chapels, schoolrooms, offices and at home. Short-sighted eyes that missed little.

Those eyes get a special mention in one of the best Hotspur histories. For "Spurs," his invaluable history of the club first published in 1956, Julian Holland visited the ageing Bobby at Wilton Road when he was the only surviving founding member. "Bobby Buckle is a direct man

In the garden at 6 Wilton Road. Bobby, as ever, in a three piece suit and boots.

with a phenomenal memory" wrote the author. "He will sit in his chair and, with his bright eyes behind a tiny pair of spectacles, debunk many of the far-fetched stories about the early days of Tottenham. He remembers how Tottenham started: he was there."

Those Sunday and Thursday journeys to the Croydon Baptist chapel were among thousands made to worship there, apparently because they valued that minister's sermons. The Buckles were so punctilious in catching the trolleybus to Croydon that when other worshippers said it

had been too wet or too cold or they were too ill they were told: "Well the Buckles were there in their seats at the back and they had much further to come."

When young William Ebenezer Buckle plucked up courage, turned his back on Suffolk poverty and came to London in 1854, the only thing of any value he brought with him was his faith. Now his son was old and prosperous but clung to his father's faith. Even so, the exact nature of Bobby's belief is hard to pin down. Chapel records show he never made the required declaration to the Croydon congregation that would formally have made him a member. Is that why he always sat at the back, not wishing to seem presumptuous? True, he may well have been a member at Claremont Street, that bleak little chapel he attended from earliest boyhood, but we are told that such membership would not have been transferrable.

This apparent anomaly does not weaken the case for his piety. Another granddaughter, Ruth Pankhurst, remembers: "Grandpa, as a Christian, believed in tithing. But he didn't just give a tenth of his income after he had paid his taxes, he tithed his gross income. He was a man of integrity." So one tenth of everything Bobby earned went to support the work of his chapel, its minister and charitable activity in the wider world.

There is no room for doubting Bobby's piety when it comes to temperance. While one family member speculates that "he may have had a pint with the lads after the game", and, after all, those key early Spurs meetings were held in pubs, but never a drop passed his lips in later life.

On the other hand, we can be fairly sure his wife, step-daughter of a publican and off-licence owner, allowed herself a covert draught of medicinal stout from time to time. Ethel even rigged the household accounts so that when Bobby scrutinised them he would not know the mysterious entry for "goods" covered a few bottles laid in for a sick adult daughter-in-law. It was not until she was a widow on a family visit to Southampton she dared try her first gin and tonic "just to see what it tasted like." The Buckles' rejection of strong drink extended even to the tea they served guests which was famously the weakest

anyone had ever tasted, or failed to taste. Family thrift extended to domestic equipment. Ethel raised an eyebrow when a married daughter bought an ironing board. Ethel had always relied on a plank balanced between two chairs.

Through all this the Buckles never rested. Why did Bobby keep working at Pedley, May & Fletcher, at least part time, well into his seventies? Perhaps to keep an eye on his insurance business.

Which brings us to the question of what he did with his considerable earnings. In short, Bobby had his own brand of insurance. It involved buying eleven properties in his old Tottenham haunts. They were on short leases which kept down their prices but provided regular rents. The gap in their ages meant he would almost certainly die before Ethel. The rents, which were always modest, would provide for her when he was gone. And that is exactly what happened. Eventually, the probate value of his estate was put at £8,236.

Ethel, who distributed the properties among the family in her will, had helped collect rents from the start. When Bobby was too lame she sometimes went alone after arranging for someone to sit with Bobby. Even into her 90s she would trot round from door to door each month collecting the cash and travelling by bus and train back to Wilton Road where it was carefully counted out on the kitchen table. To the despair of the family she still travelled alone carrying cash when old and frail until one son opened a bank account in Tottenham where she could deposit it safely.

Why did Bobby, who had not lived in Tottenham for half a century or more, buy houses there? The best guess is that through his continuing contacts with businessmen at Claremont Street he learned of likely property opportunities in Tottenham where property was probably cheaper anyway. Certainly according to James, one of his friend Samuel South's sons, the chapel was where deals were done and business information exchanged among the friendly faithful.

So, apart from his home at Merton, we find that in the 1914 voters roll for Tottenham he also appears as the owner

of a row of houses, numbers two to sixteen Spondon Road, South Tottenham. He later bought a further three properties in the borough but may have sold some of the Spondon row. Bobby was certainly a man of property.

We can only speculate how a lawyers' clerk, father of a growing family, managed such an investment. Claremont Street Chapel may have been instrumental and lawyer Pedley could have helped with any mortgage.

Throughout these changes Bobby still "kept a foot in the door" at White Cottage where he probably stayed when he had business in his old haunts such as Spurs annual meetings. So, in a way, Bobby never quite left his native streets. Yet through all those years after uprooting himself from Spurs and from Tottenham Bobby seldom if ever spoke of the club. Some acquaintances, even members of his extended family, knew little or nothing of his role in creating what in his lifetime became a sporting giant. The club grew gigantically but he pretended no interest.

It must have been a stunning surprise when in 1921 a letter landed on the doormat inside No 6 Wilton Road inviting him to do again for Spurs what he had done 20 years before when the club first won the FA Cup. This second win in 1921 was a sporting sensation with huge celebrations and a grand dinner to mark the triumph. Bobby might have thought he was forgotten, have put those early days to the back of his mind. If he did, he was mistaken. Once more his way with words was needed and once more he proposed the toast to Spurs and told again of how it all began. He had achieved the status of "legend." He was recognised, honoured, applauded. For a while.

Then Bobby returned to suburban anonymity: just another worshipper at chapel, just another clerk on the City train. "Mr Buckle" must have become an increasingly august, awesome, even revered figure among new recruits at Pedley, May & Fletcher. Gradually, and only when he was well into his seventies, did Bobby's office days become rarer. There must have been a final day when he formally retired. A speeches-and-sherry occasion. His long-dead benefactor who sent his coachman's boy Bobby to school would have liked to be there. A few slowly-spoken

At the front gate of 6 Wilton Road in the early 1950s

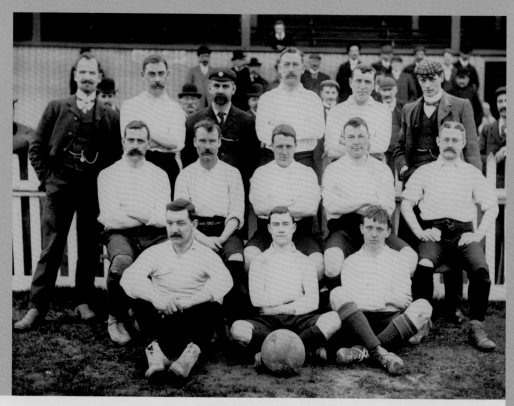

This poignant picture was the dying Bobby's last glimpse of Spurs.
He sits, with his accustomed assurance and steady gaze, on the
right of the centre rank beside his dear friend Ham Casey.

words from Bobby, whose oratory had swayed the story of Spurs; a mention of how he started work there aged 14. By then Spurs had just been born but on that most important work of his life Bobby would have been silent as he said farewell to desk work. Spurs was another time, another life, another Bobby.

When he went home after that last day at the office it was a home almost devoid of visible football mementos. Almost but not quite. He had clung to one faded photo. It was that treasured picture from almost 60 years before when he played his last game for Spurs.

This is the picture he could see from his death bed in April 1959. He had only to look at that line-up to be 13 again and back with his mates on the marshes. He saw the faces of old friends from the earliest days, their names echoing down the decades – the Caseys, Beaven, the Andersons, Jull. Now he was the only survivor of those eager boys he saw around him on that mad, momentous day under a gas lamp in Tottenham High Road when they had this wild idea.

It was just an idea ...

Acknowledgements

We are grateful for the help, guidance, encouragement and support we have received during the preparation of this book. In particular:

The Buckle Family
The Grandchildren: Philip Haynes, Ruth Pankhurst, Colin Buckle, Janet Albertini, Mary Mailer, Eleanor Kerrigan, Robert Mackman, Richard Mackman, Michael Mackman, Trina Nichols.
The Great Grandchildren: Andrew Ludlow, Ian Ludlow, Anton Mackman
The Great Great Grandchildren: Leigh Stuchbury

Tottenham Old Grammarians
Philip Nyman, Barry Middleton, Arthur Evans

Bruce Castle Museum
For permission to use the images on pages 12, 15 & 16; and their staff, in particular Deborah Hedgecock and Valerie Crosby

Enfield Museum
For permission to use the image on page 40

Tottenham Hotspur Football Club
For permission to use the images on pages 8, 22, 25, 36, 45 and 51; and their staff at THFC and THFC Archives, John Fennelly, Paul Miles, Jon Rayner, Tony Stevens, Laura Chiplin

The South family
Christopher South
Janet South
Ken Barker
Ruth Barker

Also
Daren Burney for access to the 1885 Minute Book

The late Andy Porter, former THFC Historian
Jane Porter

The pictures on page 70 are by kind permission and copyright of Sue Totham

The image on page 77 is by kind permission and copyright of D.C. Bradley (www.trolleybus.net)

The image on page 41 is by kind permission of Bob Goodwin

All other images unless otherwise stated are copyright of the Buckle family

Andrew Shoolbred
Tracey Ackland
Peter Ward
Dr Tom Doig

The San Marco and Spur Restaurants
For their hospitality and patience

And of course
Hannah Nyman
Dawn Middleton
Maureen Evans
Suzanne Mackman

Bibliography and Sources

Barker, Kenneth *South From Barley – the Story of the South Family* (Kenneth Barker 2006) ISBN 0955311403

Booth, Charles ed., from *Life and Labour of the People in London*. Vol. VII. Population Classified by Trades (London Macmillan 1896)

Borrow, George *The Romany Rye* (John Murray 1858)

Burnby J.G.L. & A.E. Robinson *Now Turned into Fair Garden Plots* (Edmonton Hundred Historical Society Occasional Paper 45 1983)

Cloak, Martin & Alan Fisher *A Peoples History of Tottenham Hotspur Football Club* (Publishing, 2016) ISBN 9781785311888

Cross, T. *The Autobiography of a Stage-Coachman* (Forgotten Books 2012)

Dictionary of National Biography, (Epitome 1903)

Grass, Tim *There my friends and kindred dwell – The Strict Baptist Chapels of Suffolk & Norfolk* (Thornhill Media 2012) ISBN 9780957319004

Hale, Matthew *Book Bookkeeping For Solicitors* (Stevens & Sons 1884)

Holland, Julian *Spurs: A History of Tottenham Hotspur Football Club*, (The Sportsman's Book Club 1957)

Jones, Charles *The Solicitors Clerk* 6th revised edition (Effingham Wilson 1906)

More, Edward *Suffolk Words and Phrases* (R. Hunter 1823)

Porter, Andy *The First 100 Years – The Pioneers of 1895* (Club Programme 8 October 1952)

Robinson, Jean *The History of Tottenham Grammar School* (Edmonton Hundred Historical Society Occasional Paper 40 1983)

Simmons, G. Wagstaffe *History of Tottenham Hotspur F.C. 1882–1944 Its Birth and Progress* (Tottenham Hotspur F.C. 1947)

Soar, Phil *Tottenham Hotspur – The Official Illustrated History 1882–1995* (Hamlyn 1996) ISBN 9780600587064

Tottenham & Edmonton Weekly Herald *The Romance of Football, The History of Tottenham Hotspur F.C.* (1921)

Wilkinson, Anne *The Butler, the Coachman and the Governess* (Oakwood & District History Society Extract from Oak Leaves Part 3 2002)

Sources

The primary sources for the book have been the minute books of Tottenham Hotspur Football Club 1885–1896 and 1898–1906 also other contemporary records held in the archives of THFC. Information of the annual general meetings, social events and match reports were obtained from contemporary newspapers including the *Tottenham & Edmonton Weekly Herald*, the *Middlesex Gazette*, *The Sportsman* and *Sporting Life*. Details of the occupancy of family homes were provided by census returns, electoral registers and rating records deposited in the London Borough of Haringey Archives at Bruce Castle Museum. Records relating to Claremont Street Baptist Chapel are deposited at the Standard Gospel Library in Hove. Reliance has also been placed on the personal memories of the descendants of Bobby Buckle and family mementoes that have been passed down to them.

Index

The Author

A journalist and broadcaster for more than 65 years, Christopher South has done most jobs in the media but admits he was a "really rotten" football reporter. He went to his first match at White Hart Lane aged 10 in 1947 (Spurs 0, Coventry 0) with his father when Bobby Buckle was a family friend. His previous books include a serious self-help guide and a series of "Grunty Fen" books which he thinks are funny.